Country Wreaths & Baskets

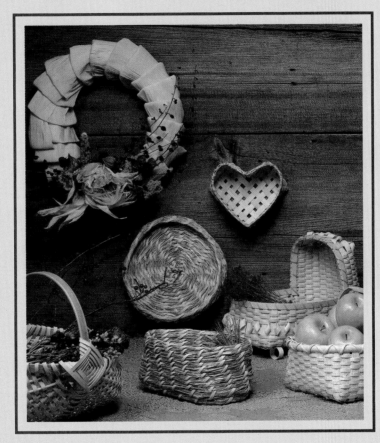

Country Wreaths & Baskets

by William C. Ketchum
with Linda Hebert

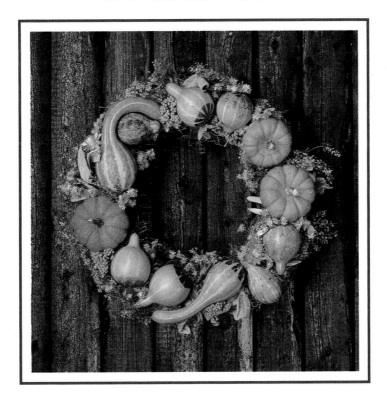

Photographs by Schecter Lee

Meredith® Press
New York

CREDITS

Illustrations: *Linda Hebert*
Botanical illustrations: *Jeanette Martone*
Photos on pages 10, 13, 16, 15, 19, 23, 32, 57, 72, 77, 87, 107, 119, 153 by *Linda Hebert*
Photos on pages 8, 11, 63, 64, 65, 67 by *Esto Photographics*
Photography Stylist: *Dina von Zweck*
Stylist Assistant: *Carolyn Mitchell*
Background Fabric: *Marimekko* on pages 137
 Laura Ashley on pages 93, 121, 125, 138, 151, 155
Proofreaders: *Leoni McVey, McVey Associates; Guido Anderau*

FOR MEREDITH® PRESS

Director: *Elizabeth P. Rice*
Assistant: *Ruth Weadock*
Executive Editor: *Connie Schrader*
Project Editor: *Vivien Fauerbach*
Editorial Assistant: *Carolyn Mitchell*
Production Manager: *Bill Rose*
Designer: *Diane Wagner*

All wreath and basket designs and supplies from Virgin Islands Reed & Cane,
Route 1, Box 960, Eureka Springs, AR 72632. Telephone: 501-253-7860.

Distributed by Meredith Corporation, Des Moines, Iowa.
ISBN: 0-696-02355-5
Library of Congress Card: 90-063667

Printed in the United States of America

10 9 8 7 6 5 4 3 2 1

Dear Crafter:

This book, which combines two of the most popular country crafts, grew naturally from the enthusiasm of two authors. I worked with author and antiques expert William C. Ketchum many years ago. From time to time, we had discussed a book on wreath- and basket-making, but the knowledge of an expert basket-maker was needed. A serendipitous meeting with Linda Hebert, who provided the detailed how-to descriptions and step-by-step line illustrations, made this project a reality. We hope you enjoy this book; Meredith® Press takes pleasure in bringing it to you.

Meredith® Press books are of the finest quality and offer projects for every level of crafting skill. Our books feature large, full-color photographs of all projects, plus easy-to-follow instructions and diagrams. We hope you find *Country Wreaths & Baskets* an inspiration, and will use it to create your own wreaths and baskets.

Sincerely,

Connie Schrader

Connie Schrader
Executive Editor

❧ Contents ☙

❧ Preface ❧

As an historian and author in the field of American decorative arts, I have always been concerned more with crafts as found objects, rather than with the process of their construction. Consequently, it was with some trepidation that I entered into collaboration on this book. At the same time, however, I was firmly convinced that both craftspeople and collectors can benefit greatly from a study which, while focusing primarily on how to make basketry and wreaths, also provides the reader with some historical context within which to place these lovely objects.

Most of us who study Americana deal with objects which are no longer made by a significant number of people (samplers and textile pictures, for example) or which are now, like modern ceramics, made in a substantially different way. Consequently, our interest in the "who," "when," and "where" of an object generally exceeds our knowledge of "how" it was made. Craftspeople, on the other hand, often turn out lovely baskets, woodenware, or ironwork without any real knowledge of the countless generations of artisans who preceded them and toiled in a similar manner to achieve a similar end.

The introductions to the how-to sections of this book are designed to provide the general reader and crafter with a feeling for the historical context in which these crafts were made, as well as with an awareness of his or her place in a rich and continuing craft tradition. They are not intended to provide an exhaustive history of the field. For in-depth information on antique baskets I recommend Gloria Roth Teleki's *Collecting Traditional American Basketry* and *The Baskets of Rural America*, or my own *American Basketry & Woodenware*. Unfortunately, no comparable book has yet been written on the fascinating history of wreaths.

In selecting a collaborator for this project I sought, and found in Linda Hebert, a person who is not only an acknowledged leader and master artisan in the craft field, but also someone who is equally interested in the interplay between history and practice, between the making of an object and its purpose.

What we discovered in the process of writing *Country Wreaths & Baskets* is that techniques have changed little over the years. A properly constructed basket or wreath takes just as much care and probably as much time as it did a century ago. True, we have

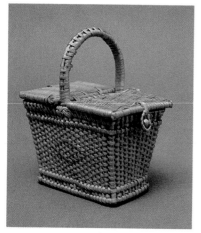

Miniature picnic basket of split reed, Asiatic, c. 1900–1920. Though a few such containers were made in this country, most were imported from China and other places in the Orient. Miniatures are highly prized by today's collectors.

modern conveniences, such as the hot glue gun and staples, but the effort and skill required remain unchanged.

What has changed, though, is the function of the objects. Wreaths, which once had great symbolic importance as awards for excellence in everything from athletics to poetry and music, and eventually, much changed, as crowns for heads of state, are now largely decorative objects for doors and mantels. Yet, even here, a hint of the past remains in the cornhusk wreaths that welcome Fall and echo ancient harvest festivals, and the pine bough and cone wreaths whose traditional appearance at Christmas is reminiscent, at least in part, of the pagan longing for the distant spring.

Baskets, too, serve many purposes. An elongated eel basket, cleverly made so that an eel or other fish following the scent of bait and swimming into it, cannot later back out, now serves admirably as a container for dried flowers or even the family's umbrellas. Other baskets, which originally held a weaver's bobbins, were adapted for the tourist trade as "comb baskets" and hung on the wall complete with mirror, brush, and comb. Today we make them for display of dried flowers.

Large containers such as bushel, produce, and wool-drying baskets, all had an important role in 19th-century household and farm economies. Now those functions no longer exist. Today we fill baskets with newspapers, magazines, kindling wood, and countless other objects, content that the baskets provide practicality, beauty, and a sense of warmth in the home.

It is this balance between the history of basketry and wreath-making and their current applications that we have striven for: to convey something of what these objects once meant to their creators and users, while at the same time offering the modern craftsperson, and those who may possibly buy his or her creations, appealing and useful designs.

One of the many wonderful things about Linda's wreaths and baskets is that they are both practical and authentic. She knows and respects the ancient traditions associated with these objects, and she never yields to a temptation to make them something other than what they are—honest, useful wreaths and baskets, which if set down in some magical way before a 19th-century craftsman would be immediately recognized and admired. What higher praise can one receive?

William C. Ketchum

❧ Glossary of Terms ❧

Awl. In basket-weaving, an ice pick type tool, used to open up spaces in the pattern for insertion of spoke or weaver ends.

Base. In wreath-making, the foundation or core material of a wreath; usually, straw, wire, styrofoam, or vines.

In basket-weaving, the bottom of a basket; in all baskets except rib baskets. The place from which basket structure originates. The base can be round, square, oval, rectangular, hexagonal, heart-shaped, or free-form.

Bittersweet vine. A deciduous North American vine which bears ornamental red-orange berries in the fall; used for wreath decoration.

Border. The finished top edge of a basket. The border may be applied separately or created from the end lengths of the spokes.

Cane. The flexible outer bark of the tropical vine *calamus rotang*; used for basket-weaving and chair seats and available in several widths.

Coiling. A method of basket construction in which materials (pine needles, grasses) are gathered together in clusters and joined with a soft binding material, such as raffia or yucca. The materials are wrapped and sewn into place in a manner that resembles embroidery stitching.

Cornshucks/cornhusks. The cream-colored shucks of a cob of corn, soft when removed from the cob, dried crisp, become soft again when soaked in warm water.

Curly. Native American detail in basket embellishment; made by twisting the woven material into a curl as it is woven.

Datu. In basket-weaving, a tropical vine that is tough and glossy like bamboo, but having the same flexibility as willow.

Double-wall. Method of basket construction which features a double-thickness of woven material; the basket is woven from the base upwards, then turned down at the rim and woven back to the base for the second layer.

Feet. Any type of carved or stick-like additions incorporated into the base of a basket; added to create height and lift the basket off the ground.

Cornhusk Wreath

Flat oval reed. The inner fiber of the tropical vine *calamus rotang*; flat on one side and slightly curved on the other; processed into lengths from 3 to 10 feet.

Flat reed. The inner fiber of the tropical vine *calamus rotang*, shaped flat like splints; processed into lengths from 3 to 10 feet; ranges in width from ³⁄₁₆ inch to 1 inch.

Floral moss. A commercially prepared gray-green moss used to cover straw wreath bases before adding dried floral material; used mainly to camouflage the wreath base.

Floral picks. In wreath-making, short green sticks which are pointed on one end for inserting in the wreath base and wired at the opposite end for attaching plant or cone materials.

Floral pins. In wreath-making, wire U-shaped pins used to join clumps of plant material to the wreath base.

Forms and frames. Round or heart-shaped bases used to permanently affix wreath materials; generally available in wire, straw, or foam.

Grapevine. The deciduous vine of the grape plant; harvested in Fall or winter, when growth of at least one-year-old plants is cut for wreath-making.

Hot glue gun. An electrically heated, hand-held gun which melts sticks of adhesive for solid-bonding craft materials; most convenient models are available in cordless styles.

Half-round reed. The inner fiber of the tropical vine *calamus rotang*, shaped in semi-circular form on the outside and flat on the inside; processed into lengths from 3 to 10 feet long.

Handle. A carrying grip for baskets; may be carved, twisted, or bent. Inserted at the completion of the basket or slid into the weaving before the finish; may match the fibers of the basket body or be composed of a different fiber.

Honeysuckle vines. The vines of the Japanese honeysuckle plant; harvested after frost when growth is dormant; may be used peeled or unpeeled for basketry.

Pairing-weave. Basket-weaving pattern created by twisting two weavers over a series of spokes; also known as "twining."

Pine needles. The foliage of any pine tree. Needles vary in length, with southern and northwestern U.S. areas producing trees with the longest needles. Basketry may be coiled with any type of needle, but the longer the needle, the easier the basket construction.

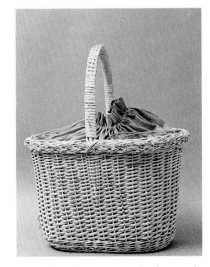

Painted willow sewing basket with satin liner, Ohio, c. 1870–1900. Baskets like this, with a drawstring top, were used to hold various sewing tools and materials. Many were painted to add a bit of color to the home.

Plain-weave. Basket-weaving pattern created by weaving over and under an odd number of spokes.

Raffia. Basket-weaving material derived from the Madagascar palm; usually used to bind coiled basketry.

Rattan. General term for tropical vine material found in basketry and furniture.

Reed. The inner fiber of the tropical vine *calamus rotang*. Processed into a variety of core shapes (round, flat, flat oval, half-round) and cut into lengths that usually range in length from 3 to 20 feet.

Rib. Part of the skeleton of a basket; the pieces upon which the basket's weavers are woven. Also known as rods, spokes, or staves. May be considered the warp of the basket.

Rod. Part of the skeleton of a basket; the pieces upon which the basket's weavers are woven. Also known as ribs, spokes, or staves. May be considered the warp of the basket.

Round reed. The inner core of the tropical vine *calamus rotang*, processed into lengths from 3 to 10 feet. Diameters range from approximately 1.5 mm to over 12 mm.

Ryestraw. Straw of the rye plant; harvested at full growth and used without seedheads for basket coiling.

Smoked reed. A factory-colored, dark brown reed; processed in the same shapes and lengths as natural reed.

Splint. In basket-weaving, the pounded inner core of hardwood trees, usually made from white oak, black ash, or hickory. Also used to describe any flat material used for basket-weaving.

Spoke. Part of the skeleton of the basket; the pieces upon which the basket's weavers are woven. Also known as ribs, rods, or staves; may be considered the warp of the basket.

Stave. Part of the skeleton of a basket; the pieces from which the basket's weavers are woven. Also known as ribs, rods, or spokes; may be considered the warp of the basket.

Styrofoam base. Round-form wreath construction; wreath materials are generally attached by sticking into the foam.

Twill-weave. A basket-weaving pattern in which the weavers are staggered over a series of spokes.

Twining. Basket-weaving pattern, created by twisting two weavers over a series of spokes. Also called "pairing."

Vine. A deciduous, trailing growth, such as grapevine, wisteria, honeysuckle, or virginia creeper, that is used for wreath or basket construction.

Weavers. The fibers that are woven over the spokes of a basket to create the finished weave; may be considered the weft of the basket.

Wicker. Any of many different styles of basket pattern weaves, especially those popular during the Victorian age. Wicker describes patterns only, not a material (wicker furniture is woven of rattan).

Grapevine Basket

✣ General Information ✣
Supplies

Bases for Wreaths

Bases for wreaths are available in wire, straw, and styrofoam. The base should provide a solid foundation for the project, and the materials used to make the wreath should camouflage the base. For example, airy, fresh evergreens are best affixed to green wire bases. Straw bases are solid enough to hold the many floral picks required to create a dried flower wreath, and the dried flowers themselves are full enough to conceal the straw. Styrofoam is suitable for light-colored materials such as popcorn or materials which require a very smooth base surface such as cranberries.

Basket Feet

Basket feet may either be purchased or handcrafted. Ours are hand-cut pine, stained to complement the oak. In the Footed Wool-Drying Basket, page 157, we used a piece of pine measuring 1 inch × 1¼ inches × 13 inches. A shelf was notched into the approximate midpoint of the pine. Then the top piece, to be woven into the basket, was trimmed down to taper from a thickness of ¼ inch at the shelf to ⅛ inch at the top.

Grapevines

Grapevines are often found trailing on the ground or climbing trees; tree-climbing vines can be harvested most easily by pulling and cutting. Gather them at any time of year, cutting only brown vines which have been through a winter. Green vines which have not been hardened by winter frosts will deteriorate. If you harvest in spring or summer, be on guard against snakes which may inhabit the area.

Use hand-held pruning shears to cut a vine free, but don't trim the overall length of the vine unless you must. Ten to 20-foot lengths are perfect. Later, you'll be shortening some pieces for use as spokes, but you'll want the weavers to be as long as possible.

At home or in the field, trim off the leaves but do not remove the curly tendrils. Keep as much of the bark as possible, removing only the very shaggy sections.

Grapevines generally have several branches at the end near the new growth. Prune off the extra pieces so that you have lengths of single strands. Grapevine does not need to be soaked and may be woven "as is."

Honeysuckle Vines

Gather honeysuckle vines any time in the Fall after a few hard frosts, when the plant is no longer "in the sap." Pull a single vine from the plant, and cut it free when tugging no longer releases any further length. Coil each length of vine into a circle about 7 inches in diameter, pick off any remaining leaves, and tuck the end of the vine into the coil a couple of times to prevent unrolling. Never shorten any of the long pieces. You'll soon see that long weavers are preferable to short ones. Where branching tributaries of the vine occur, make a smooth cut close to the main vine, creating separate strands. Gather equal amounts of spokes and weavers—the weavers will be about the diameter of spaghetti, and spokes will be about twice that diameter. A large shopping bag full of coiled honeysuckle vine will be approximately the right amount for a large wreath or a small basket.

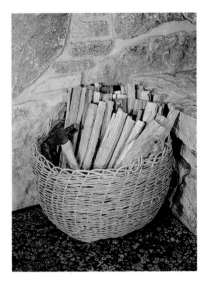

Bushel Basket

If you want a rustic-looking honeysuckle basket with the bark on, soak the vines in warm water for a few hours, or however long it takes to make the vines flexible. If the vines crackle like kindling when you begin to weave, put them back into water to absorb more moisture. If they are especially dry and hard—for example, if gathered after a long drought—they may even take several days to absorb sufficient water. The amount of time required for soaking depends upon the amount of moisture in the air (and therefore in the plants) when they were gathered.

If you plan to use honeysuckle from which the bark has been peeled, as in our illustration, simmer the vines in a large pot for about a half hour. Then, check for loosening bark. The bark has two layers; if you're lucky, both layers will slip off in one motion. Usually, the brown outer bark will slide off easily, but the next layer, which is practically transparent, requires a bit more effort.

After removing the brown outer bark, use your thumbnail, a jack-knife, or a paring knife to loosen an edge of the thin inner layer. Once an edge is pulled away, this layer can be stripped to reveal a superb, waxy-textured vine underneath. The vine's inner surface will be extremely smooth. If you leave patches of the thin layer on the vine, they will probably fray off as you weave. But be sure to remove these scraps as you weave, since you cannot easily remove the dry, shaggy remnants once the wreath or basket is completed. As with the un-peeled vines, re-soak the peeled vines until they are flexible enough to weave without breaking. Later, soak the partially finished basket any time the spokes or weavers start to dry out and break.

Once the vines have absorbed water, they will start to darken and change color. Check the vines for signs of darkening if you don't use them by the second day. The darkening, of course, is not a detraction.

The color of the finished product will be determined by how long the vines have soaked and is just a matter of taste—or chance. After the basket is completed, and the vines begin to dry out again, the process will be reversed. The color will get lighter as the basket dries over a period of days, weeks, and months, the degree of lightness depending upon the humidity.

Honeysuckle baskets age magnificently. The spokes and weavers seem to get smoother with age, the colors soften, and the fibers strengthen.

Pine Needles

Gather brown pine needles and air dry them for a day or so. Long-needled pines from our Southern and Western North American trees produce outstanding baskets. Their needles, some of which can be more than 12 inches in length, are extra long. Even short needles can be used with great success. Do not use green pine needles unless you dry them for at least a week or two. Drying the needles will ensure that they will shrink no further after you attach them. If you stitch fresh green needles into a basket, they will look and smell terrific at first, but a couple of weeks after coiling, the basket will dry out and loosen all of your stitches at the same time.

Reed and Cane

Because of their strong and durable fibers, reed and cane are the materials most often used in basket weaving. Both come from the tropical vine *calamus rotang* and are generally known as "rattan." The outer bark of this tropical plant is processed into the shiny material called "cane." The inner core of the plant provides "reed." Both materials are sold in premeasured units called "bunches" or "hanks." Each bunch weighs approximately a pound. Cane is also sold by the strand—generally 7 to 10 feet long. The baskets in this book usually require a fraction of a pound of each of several different sizes of reed. By purchasing a pound bunch of each size required, you will have enough for more than one basket. Occasionally, only 1 or 2 strands of a material are required for use in a basket. However, only cane, not reed, is available by the strand.

Cane, with its shiny bark exterior, is completely flat. It is available in various widths described as fine, fine-fine, super-fine, medium, and wide binding. In this book, we use medium and wide binding cane.

Reed is processed into round, flat, and flat oval lengths. Round reed is completely circular in shape, with the diameter, measured in millimeters, ranging from toothpick size to pencil size. The flat reeds are splints that range in width from 3/16 inch to about 1 inch. There is also a "flat oval" reed—flat on one side and slightly curved on the

Pine Needle Basket

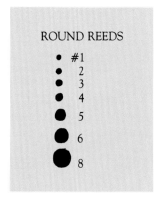

ROUND REEDS

- #1
- 2
- 3
- 4
- 5
- 6
- 8

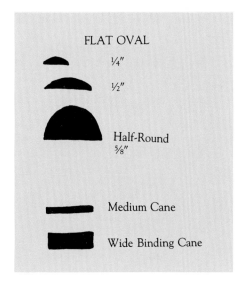

FLAT OVAL

¼"

½"

Half-Round
⅝"

Medium Cane

Wide Binding Cane

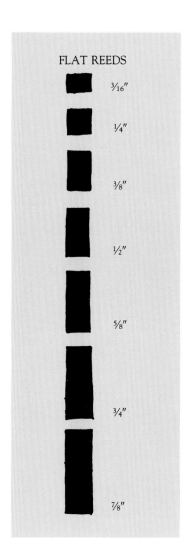

FLAT REEDS

³⁄₁₆"

¼"

³⁄₈"

½"

⅝"

¾"

⅞"

other. The curved side is used for handle stock and for the bands on basket borders. Because they are made from natural materials, the processed material varies in length, usually from about 4 to 10 feet.

Although both reed and cane are extremely brittle when dry, they are extremely flexible after just a few minutes of soaking in water. To prepare for soaking, wind individual strands of material into coils about 5 inches in diameter, keeping the flat reeds separate from the flat oval reeds. Soak in water and check after 20–30 minutes. Never soak reed longer than a couple of hours, or it could discolor permanently or become mushy.

Before storing unfinished materials, prevent mildew by being sure that everything is completely dry. Never wrap vines in plastic. If a basket or material becomes mildewed, soak it in a bleach solution of one-half cup bleach to a gallon of water.

Maintaining flexibility as you weave is most important. Re-soak a basket anytime the spokes or weavers become dry.

The most elementary and routine technique in basket weaving is the splicing of weavers. To splice flat reeds, the beginning of a new weaver is placed directly on top of the end of the last weaver, overlapping an inch or two. The overlapping cut ends are then arranged so that they are hidden by the spokes, thus making the weaving appear continuous and uncut.

Round reeds are best spliced with the end of the last weaver trimmed and tucked down next to a spoke. The new weaver is then tucked next to the previous spoke so that the old and new weavers cross for 1 stitch. An awl is sometimes necessary to open up the space next to the spoke.

Splints

Oak splints can be purchased in 1-pound bunches. However, because they are extremely expensive, they also are sold by the individual piece. A single splint is usually about 8 feet long. The age and dryness of the splint will determine the length of soaking time. Five or 6 hours are usually required at first. If you put the project aside temporarily to resume it on another day, an additional 3 hours may be needed to return flexibility to the fibers.

Splints are critical to the success of your basket. It is important that the splint not crack. If a splint shows signs of cracking, soak it again and test it an hour later.

Straw

Ryestraw, or even common mixed grain roadside materials, may be used for coiled basketry. Cut the grain at ground level and dry it in the sun. When it is dry, break off the grain tops, leaving just the stalks. Clean the straw by removing weed stalks and other foreign materials.

Tools and Fasteners

The few tools required for wreath-making are usually readily available in most households. Pruning shears or heavy-duty kitchen shears are used to cut everything from ribbon to dried materials. Wirecutters are used for work with spool wire.

Craft wire, which can be purchased either on the spool or in cut lengths, is used to create wreath hangers and to fasten plant and cone materials. Floral picks and floral wires are specially designed for the fastening of clusters of dried materials such as herbs, flowers, and pods.

A hot glue gun is helpful when joining both heavy materials (shells, gourds) and light dried materials (herbs, pods, flowers) to the wreath. The introduction of the glue gun has facilitated the use of materials such as seashells, which often were too heavy or bulky to be attached properly to a wreath base. With hot glue it is now possible to attach any kind of shell. The glue flows easily and quickly adheres to the shell's irregular surfaces and to the rough texture of the straw. Before using any glue gun, read the safety precautions provided by the manufacturer.

For basketry, a small pair of pruning shears is used to cut weaving materials, and an awl, a tool similar to an ice pick, is used to splice new weavers into a basket.

Cleaning and Finishing Tips

Wreaths should be cleaned only by a light, careful dusting, or by vacuuming from a short distance. Proceed carefully and never vacuum fragile materials such as herbs or dried flowers.

Baskets may be soaked once a year, or less frequently, to remove dust and to keep them moist enough to avoid cracking. However, what you decide depends upon where you live and where you store your baskets. Baskets kept in a moist, tropical climate probably never require soaking, while baskets kept in a hot, dry environment, which promotes cracking, must be soaked frequently.

Reed and cane baskets can be painted with household spray paint to achieve a wicker look, or they can be stenciled with stencil paints for a country-style decorative effect.

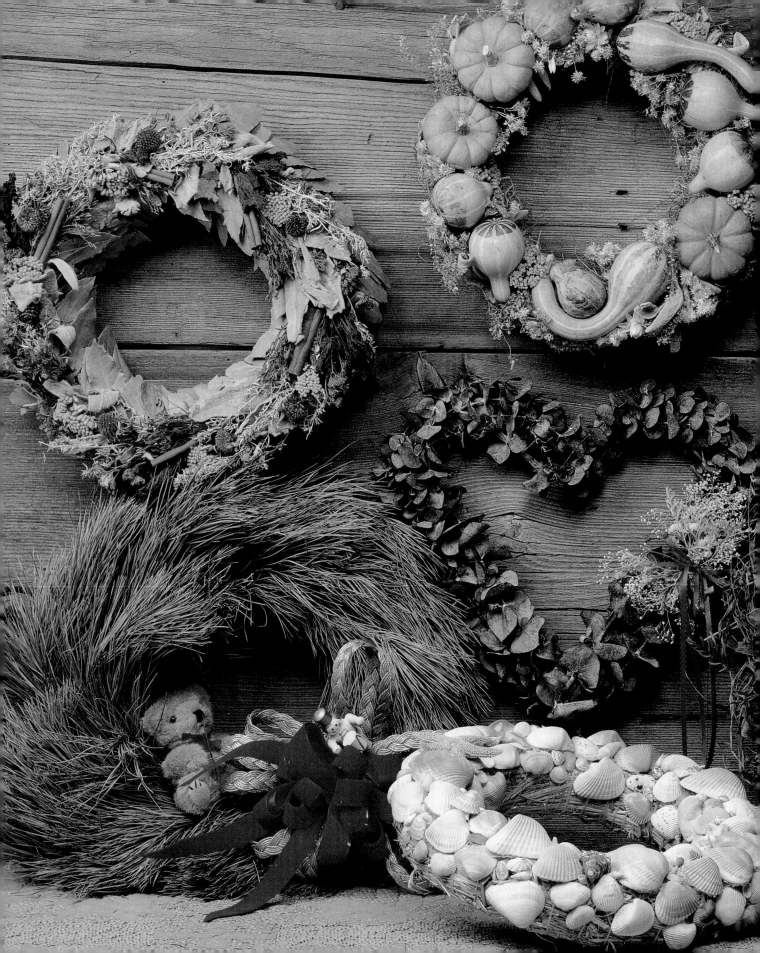

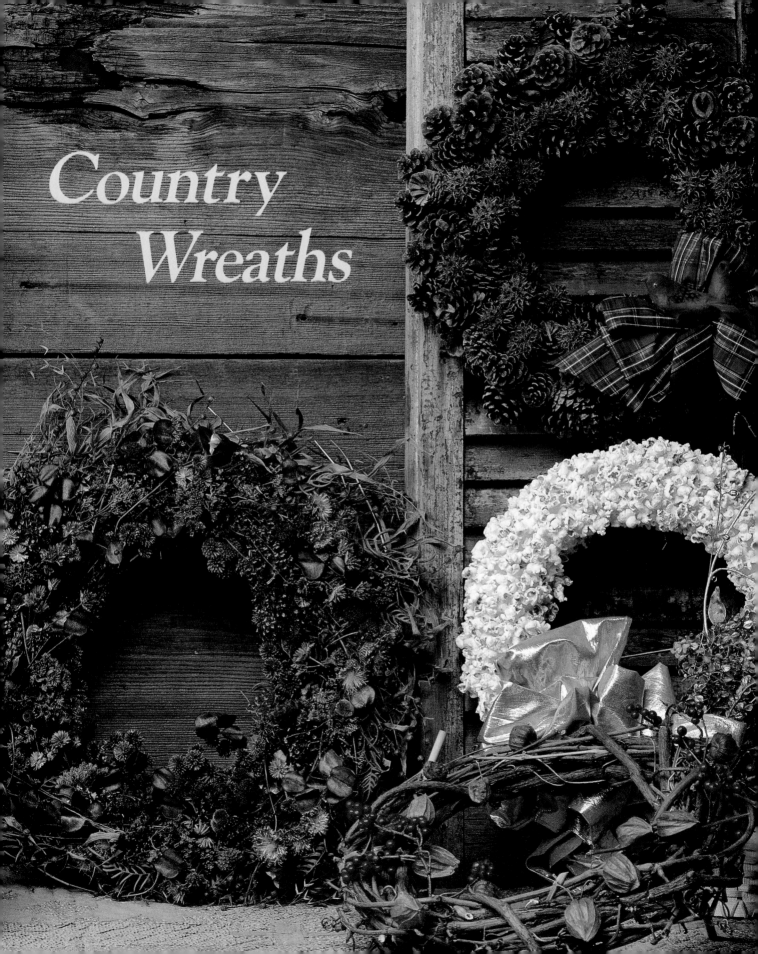

Country Wreaths

❧ Introduction to Wreaths ☙

Those of us who make, cherish, and admire the myriad of wreath forms are often unaware of the long and fascinating history of these lovely objects. Yet wreaths have been with us for thousands of years, and our aesthetic appreciation reflects a longstanding tradition steeped in mythology and religion.

First, there is their form. The traditional circular wreath symbolizes the ancient belief in a continuous, indivisible ring of life: the birth, death, and rebirth mirrored in the passage of the seasons in both nature and human life. This belief is supported by the use of natural materials—flowers, grasses, and herbs—in the creation of many wreaths. Thus, evergreens in winter express the hope of coming spring, and wreaths of gourds, dried field flowers, or wheat commemorate the harvest season.

This triumph of life over death is reflected in the role the wreath has played in human history. The earliest known example, over 4,500 years old, was found by archaeologists on the sarcophagus of Pharaoh Sekemket of Egypt. Another such garland, from the tomb of a Roman citizen buried in Egypt some 2,000 years ago, is in a collection of the British Museum. Also among British memorabilia is a 19th-century wreath which was removed from the coffin of Prince Albert by his grieving spouse, Queen Victoria.

In all three cases, the symbolism was the same: the garland attested to the fact that the deceased will have eternal life. This old custom is observed today by placing a wreath of dark leaves and a black ribbon on the door of a house to which death has come.

Wreaths also are used to bestow special recognition and honor upon successful athletes. We all are familiar with the crown of laurel awarded for athletic prowess and the expression "earning your laurels," or its opposite "resting on your laurels." But, few realize how important the simple ringlet of flowers or leaves was to our forebears.

The Greek word for wreath is *diadema,* "diadem" in English, "a thing wound around," that is, a band of fabric wrapped around the brow of one who is in some way exalted. Among the Greeks this person was often an athlete. Thus, winners of the Pythian Games at Delphi received a circlet of laurel leaves. Those who triumphed at the Ismian Games in Corinth were awarded wreaths of pine, and winners of the Olympic Games in Olympia, ringlets of olive leaves. The prizes at the fourth Greek festival, the Nemean Games in Nemea, were garlands of parsley.

Laurel

However, wreaths have also been worn by many a non-athlete as well, and the custom of "crowning with the laurel" extended far beyond the Greek isles. The Chinese bestowed wreaths of olive upon those who excelled in poetry and other literary arts, and the Romans wore garlands of oak and laurel in celebration of military triumphs. When Julius Caesar was crowned in Rome with a laurel wreath, the garland took on new significance—namely, the mark of royalty. Indeed, the very word "crown" is derived from the Latin *corona,* meaning "wreath" or "garland."

So the simple wreath became a crown: first, a simple diadem of silver or gold and eventually, by the Middle Ages, a massive jewel-encrusted headpiece calculated to overawe the beholder impressing all with the power and wealth of the wearer.

Among common folk throughout the world, wreaths continued to have a mystical importance closely connected to the cycle of life. In a number of cultures a woman might indicate acceptance of a suitor by presenting him with a circlet of birch; a dreaded rejection came in the form of a few twists of hazel. Arab brides wore garlands of orange blossoms to assure their fertility, and in Greece it is still the custom for those in the wedding party to adorn themselves with wreaths made from marjoram, myrtle, or quince, all in the hope that this might guarantee a happy union.

Wreaths made in the Swiss Alps during the 18th century were adorned with sugar and spices symbolizing both earthly sustenance and hopes for a glorious future, while small mirrors dangling from the circlet were designed to thwart evil spirits, who were repelled by the sight of their own features! Miniature diadems of baby roses or daisies worn or carried by American brides symbolize youth, fertility, and hope. And, if all goes as planned, the modern couple, like their ancient Athenian counterparts, might hang a brightly-colored wreath on the door to announce the arrival of a new member of the family!

Wreaths also have religious significance. The legend of Christ mocked by a crown of thorns is well known, and it is thought that the headbands circling the heads of Chinese, Indian, Greek, Roman, and, of course, Christian deities are stylized wreaths reflecting their sanctity as well as their power and high station.

Not only the wreath itself but the materials from which it is made may have deep significance for many. Earlier cultures were more closely attached to the soil than our contemporary culture is, and the worship of trees and plants as symbols of divine energy was coupled with a highly specific cosmology relating to the powers and attributes of specific flora.

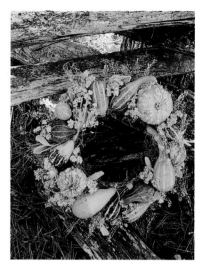

Gourds and Dried Materials Wreath

Fern

Mistletoe

A well-known example, one which still retains its power, is mistletoe. When we weave it into a Christmas wreath or hang it above a door, we are, according to tradition, recalling a custom of the Druid priests of early Britain or even the licentiousness of the ancient Saturnalia festival. For these early peoples, mistletoe was a bestower of life and fertility, protection against poison, a healing potion, and an aphrodisiac.

Less exotic materials are the corn, wheat, and other grains that are used in many Fall wreaths. All are important to us today and were vital to the ancients who celebrated the harvest with elaborate ceremonies, including feasting, dances, the bringing in of the corn mother (the last sheaf from the field clothed in a dress and ribbons and set up in the barn to encourage next year's crop), and the crowning of the head reaper with a ringlet of cornshucks and flowers.

Holly is another plant with religious significance. Christian legend claims that Christ's cross was made of holly wood and that the berries of this tree represent drops of Christ's blood. Accordingly, the plant is considered a cure for everything from smallpox and gout to rheumatism and asthma. Yet, like so many herbs and plants, it may also cause trouble. In Wales it is thought unlucky to let a holly wreath hang after the New Year, and in Germany some people avoid treading on the berries.

More benign is the traditional laurel, which makes a beautiful wreath. It is believed by some to be a love charm, and in England a man and woman who break a branch in two, each saving a portion, will remain lovers. Another old practice suggests that burning laurel leaves may bring back a wandering spouse. The American variety of laurel, known as mountain laurel, may not be entirely beneficial, for its leaves and roots are poisonous!

Wreaths made from herbs may incorporate a variety of plants, all with specific properties. Sage is recommended for headache, laryngitis, and epilepsy; a garland of sage was once used as protection against the plague. Rosemary was thought to improve the memory (hence Ophelia's lament, "Rosemary, that's for remembrance"), and Greek students wore circlets of the herb while studying for examinations. Garlic was long credited with the power to drive away evil presences such as vampires, witches, and werewolves, as well as the dreaded "evil eye." Basil is one of the most controversial herbs, for it is dear to lovers in Italy and a symbol of hatred among the Greeks, a propagator of scorpions as well as an antidote to their stings—appropriate enough for an herb which the Romans believed must be planted amidst curses in order to flourish!

Sage

These are but a few of the herbs favored by wreath-makers. So it would appear that, when we hang such garlands upon our door or mantel, we echo ancient traditions and perhaps invoke powers of which we never dreamed.

One of the most charming and interesting aspects of wreath-making is the old language of plants and flowers. Since many plants have a traditional meaning or association—the daisy, for example, is associated with innocence—it is possible to make a wreath for a friend or loved one that sends a special message. To facilitate this worthy objective, a few of the more common plants with their appropriate associations are listed here.

Armed with this vocabulary, you can create lovely wreaths, and at the same time send a message known only to you and the recipient.

Bittersweet

Bittersweet: harmony

Fern: sincerity

Holly: hope

Ivy: friendship

Lavender: devotion

Mistletoe: love

Pine: humility

Sage: wisdom

Rosemary: remembrance

Gourds: resurrection

Laurel: triumph

Oak: forgiveness

Wheat: staff of life

Mint: virtue

Verbena: purity

Azalea: temperance

Violet, white: innocence

Yarrow: solace

Thyme: courage

Bay: delight

Mint

Ivy

❧ 1 ☙
Pine Bough Wreath with Toys

BASE wire wreath frame, 12 inches in diameter

MATERIALS pine boughs, medium-gauge wire on a spool, small toys: teddy bear, brass locomotive ornament, alphabet blocks

BOW MATERIALS red velvet ribbon (about 3 yards), paper braid sprayed with gold paint (about 3 yards)

TOOLS wire cutters, scissors

SIZE 15 inches

INSTRUCTIONS

1. Securely fasten the end of the spool wire to the top of the wire wreath form. You will be using the wire in one continuous length, so do not cut the wire from the spool. Most wire wreath frames are three-dimensional, thus providing three working levels: top, outside edge, and inside edge. For best results, wire the pine boughs to the top level first, then to the outside circle, and finally, to the inside circle.

2. Place a cluster of pine needles on the wire frame and wrap tightly around the cut ends 3 or 4 times.

3. Without cutting the wire, place a second cluster of pine needles on top of the first, layering it so that the new cluster is about 3 inches away from the first. Wrap the new cluster in the same manner as the first.

4. Continue around the circumference of the wreath, spacing the clusters evenly and wiring tightly. When you have completed the circle, lift up the first cluster and fasten the last section so that the wire is hidden underneath.

5. Attach pine needle clusters to the outer edge of the wreath, and then to the inner edge in the same manner.

6. Make a bow of paper braid and spray it with gold spray paint. Make a proportionately smaller bow of red velvet. The wires that hold each of the bows together will be used to attach the bows to the wreath. Wire the paper braid bow to the wreath first; then attach the velvet bow on top of it.

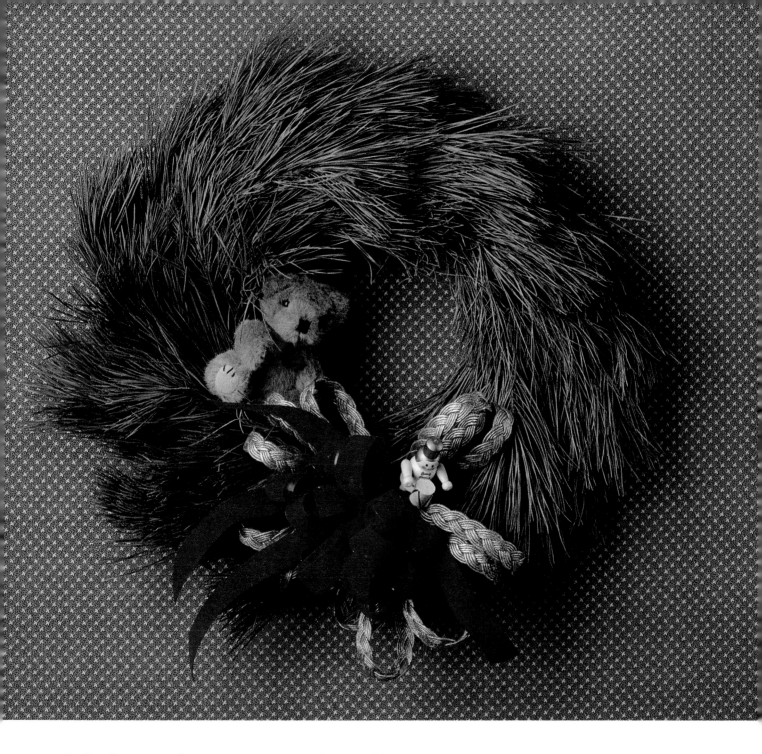

7. Lastly, use a glue gun to permanently assemble a miniature toy sculpture of blocks, teddy, train, or whatever other seasonal accents you wish to use. When the glued sculpture is dry, use wire to join the whole piece to the center of the wreath. If you don't want to join the toys together permanently, you can simply wire these individual units to the wreath.

2

Pine Cone Wreath

BASE wire wreath frame, 12 inches in diameter

MATERIALS pine cones, sweet gum balls, hickory nuts and husks, medium- or heavy-weight wire

BOW MATERIALS 2-inch wide plaid ribbon (about 4 yards), wire-footed redbirds (2)

TOOLS hot glue gun, wire cutters

INSTRUCTIONS

1. Attach a length of wire to each pine cone by folding about 8 inches of wire in half and sliding the loop into the cone near its bottom end. Twist the wire to secure the loop. The length of wire will vary depending upon the size of the pine cone that you're using, so be sure to make up the first one and attach it to the wreath frame, checking to see that you have enough length to attach it firmly to the frame.

2. Most wire wreath frames have 3 levels: an outer ring, an inner ring, and a center ring, which is higher than the other 2. Since the center circle and highest level of the wreath will be the focal point and include accent pieces such as sweet gum balls or hickory nuts, choose the materials for this section and put them aside for attachment last.

3. Attaching 1 pine cone at a time, wire the cones side by side around the outside and inside rims of the frame. Twist the wires of each cone tightly around the frame. The pine cones attached side by side will rest against each other, and provide the support necessary to keep the cones in place. As you work, decide whether you want each cone to point outward or upward—or in a combination of the two. Refer to the photo for an example.

4. After the outer and inner rims have been wired with pine cones, wire the center circle with cones in the same way.

5. Next, using the glue gun, attach the sweet gum balls, the hickory nuts and husks, and whatever other materials you choose, into the nooks and crannies of the wreath. The pine cones should rest solidly together, but there will still be adequate space to attach additional materials on the surface of the wreath.

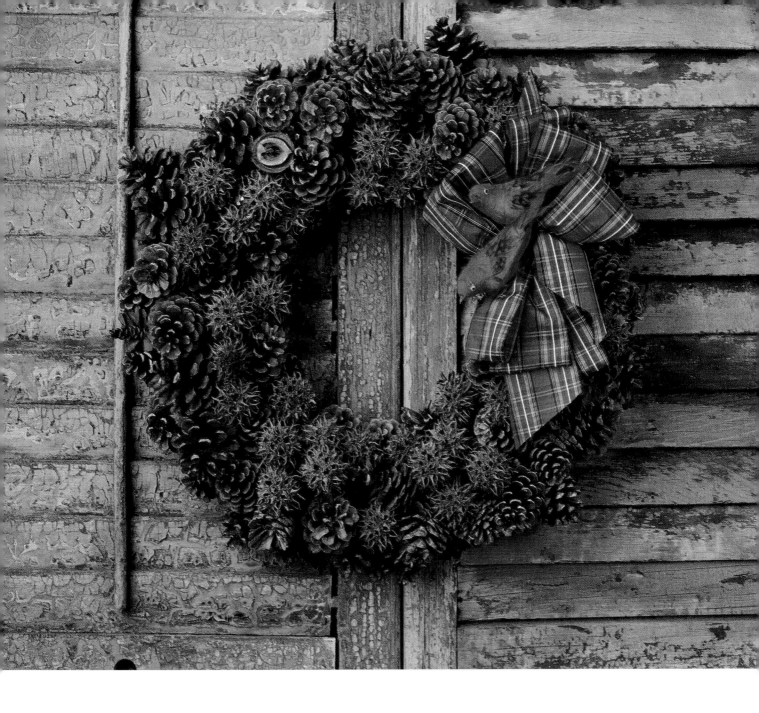

6. Make a crisp bow of 2-inch wide plaid ribbon, joining it with a length of wire long enough to be threaded back into the wreath. Then attach the 2 redbird figures onto the center of the bow by using their wire legs. Such birds, with wires in the place of legs, are readily available in craft and hobby stores.

7. Finally, holding the bow just above the area where you wish it to be fastened, carefully insert the long wire ends through the pine cones to the back side of the wreath. Pull up the ends until the bow is securely in place and twist the ends to finish.

❧ 3 ☙
Popcorn Wreath

BASE styrofoam, 12 inches in diameter

MATERIALS popcorn, hydrangea, pussywillows, wheat, laurel leaves, dried branches, medium-gauge wire, gold spray paint

BOW MATERIALS gold moiré fabric (about 3 yards)

TOOLS hot glue gun, wire cutters

INSTRUCTIONS

1. Prepare the popcorn a day before you start to work on the wreath; stale popcorn breaks less easily.

2. After applying glue to the back of each popped kernel, press the kernels into place, side by side, until the entire styrofoam base is covered. Because the base is the same color as the popcorn, whatever small bits of styrofoam show through will be scarcely noticeable. If you want a fuller-looking wreath, you can add a second layer of popcorn over the first.

3. You'll undoubtedly develop a smooth working rhythm as you assemble this wreath, but, because the pieces of popcorn are so small, just as you establish a rhythm of "glue and press, glue and press," you run the risk of burning yourself with the hot glue gun. As a precaution, have a glass of water nearby to dip your burned finger into if need be.

4. Once the popcorn is attached to the wreath base, prepare the remainder of the materials. Resting the dried materials on newspaper in a well-ventilated area, preferably out-of-doors, spray them all with gold spray paint. Be sure to turn the materials over so that the paint reaches all sides.

5. Let the paint dry for about an hour, and prepare your gold moiré bow. Yardage may be cut into 16-inch strips and joined on the bias to make a 5- or 6-foot length of bow material. Fold the length in half across its width, with right sides together. Stitch down with a long seam, leaving 1 end open. Turn right side out to make a 7½-inch wide ribbon, and hand-stitch the opening. Form into a bow by folding the material back and forth. Gather at the center and twist

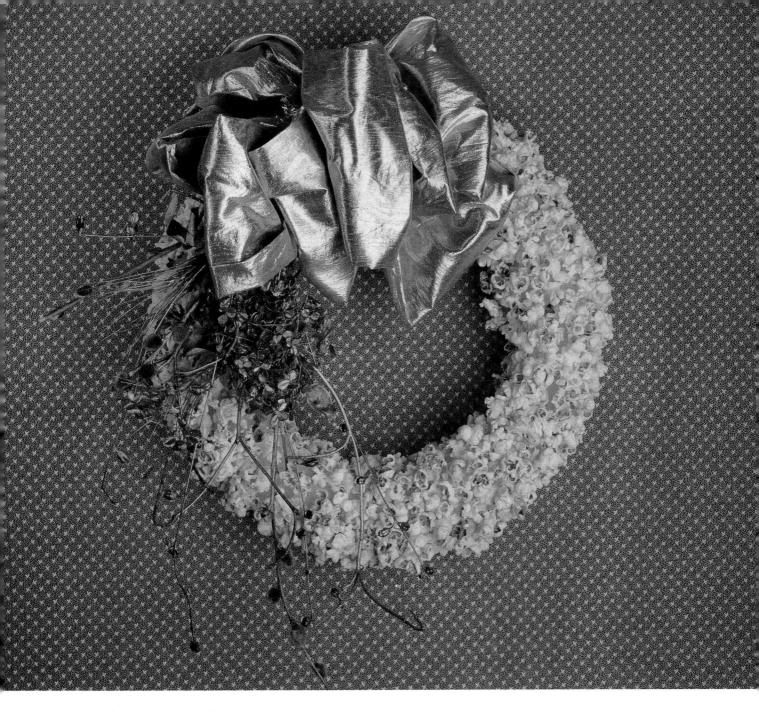

a length of wire tightly around the middle. The ends of the wire should be long enough to encircle the width of the popcorn-covered base.

6. Make a decorative bouquet of your dried materials and fasten the bouquet together with wire. Place the gold bow on top of the bouquet, hiding the wire. Then wrap the ribbon's wire around the body of the wreath and twist-tie it firmly at the back.

❧ 4 ❧
Holly Wreath with Candy Canes

BASE wire wreath frame, 12 inches in diameter

MATERIALS holly (2 shopping bags full), medium-gauge wire on a spool

BOW MATERIALS red velvet ribbon, candy canes, medium-gauge wire

TOOLS hot glue gun, gloves, wirecutters

SIZE 14 inches

INSTRUCTIONS

1. Because some varieties of holly have very sharp-edged leaves, be sure to use protective work gloves. Securely fasten the end of the spool wire to the top of the wire wreath form. You will be using the wire in one continuous length, so do not cut the wire from the spool. Most wire wreath frames are three-dimensional, thus providing three working levels: top, outside edge, and inside edge. For best results, wire the holly to the top level first, then to the outside circle, and finally, to the inside circle.

2. Place a few sprigs of holly on the wire frame and wrap tightly around the cut ends three or four times.

3. Without cutting the wire, place additional sprigs of holly on top of the first sprigs, layering them so that the new holly is about 3 inches away from the first. Wrap the new holly in the same manner as the first.

4. Continue around the circumference of the wreath, spacing the sprigs evenly and closely together for fullness. Keep the wire tight. When you have completed the circle, lift up the first sprigs and fasten the last section so that the wire is hidden underneath.

5. Attach holly sprigs to the outer edge of the wreath, and then to the inner edge in the same manner.

6. Make a bow of red velvet and secure with wire. With the glue gun, join two candy canes together at right angles as shown in the

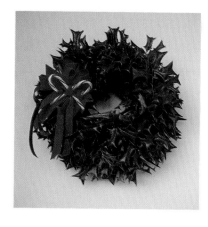

photograph. Use a second length of ribbon to attach the canes to
the center of the bow. Finally, wire the completed bow to the body
of the holly wreath. When deciding where to display this attractive
wreath, remember that holly wreaths are best used outdoors, where
the cold temperatures will keep the holly from drying out.

Holly Wreath with Candy Canes **33**

❧ 5 ❧
Gourds and Dried Materials Wreath

BASE straw, 12 inches in diameter

MATERIALS gourds (about 1 dozen, small), strawflowers, lamb's ear, peppergrass, other dried flowers or pods

TOOLS hot glue gun

SIZE 14 inches

INSTRUCTIONS

1. Decide on a pleasing arrangement of gourds by first arranging them on the table around the outside circumference of the straw wreath. Since gourds are available in crookneck, straight, smooth, and bumpy varieties, it's helpful to plan your layout first, rather than as you work, to ensure that the wreath has a well-balanced appearance.

2. Using a hot glue gun, apply a generous amount of hot glue to the back of a gourd and press the gourd firmly into position on the wreath. Hold in place for about a minute to ensure a solid bond. Repeat with the rest of the gourds. When all the gourds have been attached, a substantial amount of the straw wreath probably will be showing. But since the color and texture of the straw are compatible with the color and texture of the gourds, think of this as a positive element in the design.

3. Gather together the dried materials of your choice. We've selected lamb's ear, peppergrass, strawflowers, and some assorted dried wild-flower seedheads. Balance the color layout by gluing the materials at evenly spaced points around the circumference of the wreath. First glue the lamb's ear, attaching it in small clumps. (Lamb's ear, by the way, is best attached when it is fresh from the garden, since it becomes very brittle when dry.)

4. Next, glue all of the strawflowers in the same manner. To glue, apply a dab of hot glue to the wreath and press the materials into place, holding about 30 seconds. Fill in around the gourds with the rest of your materials, creating fullness to round out the wreath.

5. Lastly, attach a string, raffia, or wire hanging loop to the back of the wreath.

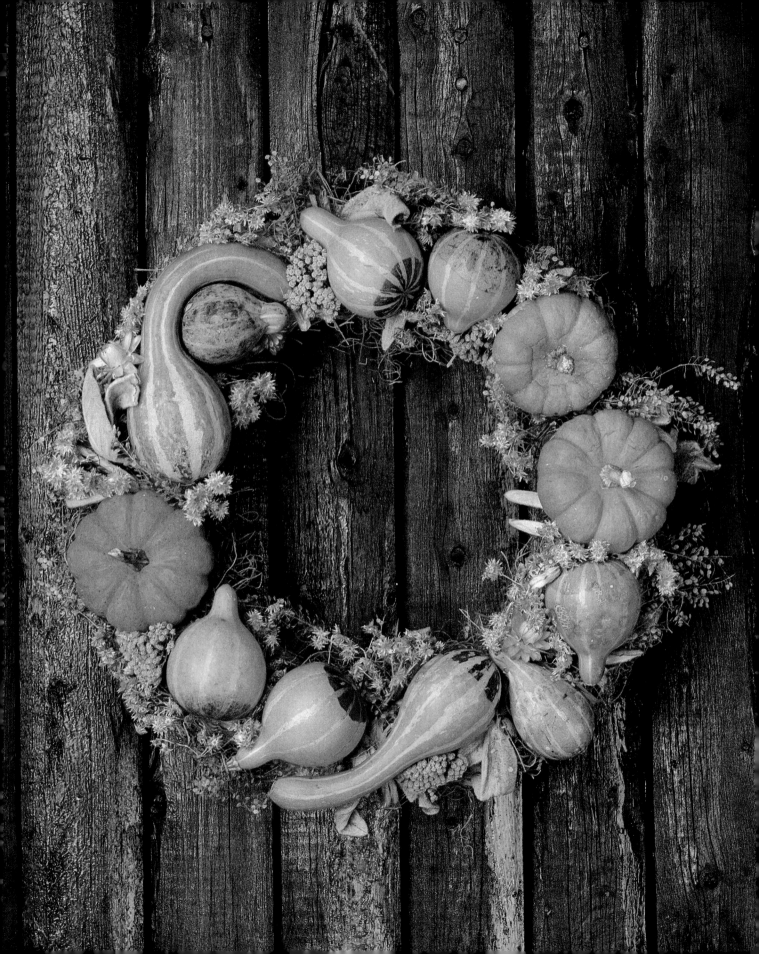

❧ 6 ❧
Cranberry Wreath
with Fresh Evergreens

BASE styrofoam, 12 inches in diameter

MATERIALS cranberries, fresh green pine needles, holly leaves, chrysanthemums, water-tubes, toothpicks, candles

TOOLS hot glue gun

SIZE 14 inches

INSTRUCTIONS

1. First, mark the candle positions for this table centerpiece by twisting the candles about ½-inch into the styrofoam base. Then set the candles aside until other base materials are prepared.

2. Pierce each cranberry with a toothpick and attach it to the styrofoam base. Place the berries close together so that the base is completely covered except for the space marked off for the candles and, of course, except for the flat side of the wreath that rests on the table.

3. When the styrofoam is completely covered with berries, twist the candles firmly into place. If desired, floral clay or hot glue can be used for additional support.

4. Next, tuck the stem ends of fresh, green pine needles into the base around the candles. Place holly leaves on top of the pine greens, inserting their stem ends firmly into the styrofoam.

5. To complete the wreath, prepare water tubes for chrysanthemums and either glue or tuck them into the greenery around the candles. If you are planning to use the wreath only 2 or 3 days, you may forego the floral tubes and tuck the chrysanthemums directly into the base. Or, if you want the wreath to last longer, you may replace the flowers every few days. The cranberries and greens should stay fresh for about 2 or 3 weeks, depending upon the temperature of the room in which the wreath is displayed. For extended life, keep the wreath in a cool place when you're not using it as a decoration.

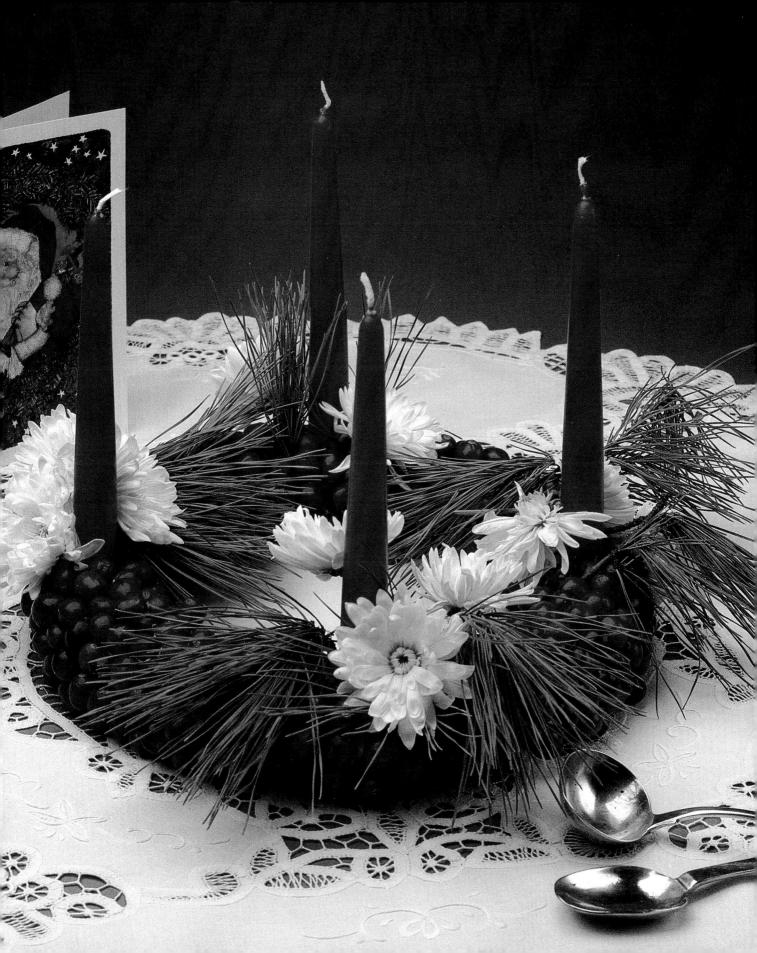

❧ 7 ❧
Grapevine Harvest Wreath

BASE grapevine, 18 inches in diameter

MATERIALS grapevine, eucalyptus, dried floral moss, Chinese lanterns, purchased cornhusk chicken or duck, heavy-gauge wire

BOW MATERIALS cornhusks (a few husks)

TOOLS hot glue gun, pruning shears

INSTRUCTIONS

1. For this large, sturdy grapevine wreath gather dry, brown grapevines after the first frost. First year's green growth is not suitable and will deteriorate. Using a large bucket as a mold for the wreath, wrap the bucket with the grapevines.

2. After you have ¾ of the vines in place, slide the wreath off the mold, and finish wrapping the final rounds of the grapevine. This may be accomplished in a couple of different ways. One way is to continue wrapping in the same direction while weaving the grapevines in and out of the wreath. This will bind the wreath together.

3. An alternate method is to wind the vines in the reverse directions for the last 2 rounds. Continue to weave in and out of the wreath as suggested in Step 2, but by reversing direction, create a harmonious zigzag in the wreath design. Our photo shows this type of finish.

4. Use heavy-gauge wire to twist a wire hanger onto the back of the wreath. Loop a 12-inch length of wire around a few vines at the back. Twist tightly several times. Then double over and twist again, making a sturdy, hanging loop.

5. Finish decorating while the grapevine wreath is hanging on the wall. First glue on a bed of dried floral moss. Next, attach the bird figure to the bed of moss. Our bird is a cornhusk chicken—an imported, purchased bird with dyed cornhusks cut and glued onto a balsa wood body and wire in the place of feet so that the bird can be wired directly to the grapevines. If your bird has no such wires, it can be hot-glued in place.

6. Next, weave the eucalyptus branches around the base of the bird, reinforcing with hot glue as needed. Likewise, attach branches of Chinese lanterns as desired to the bed of moss and eucalyptus.

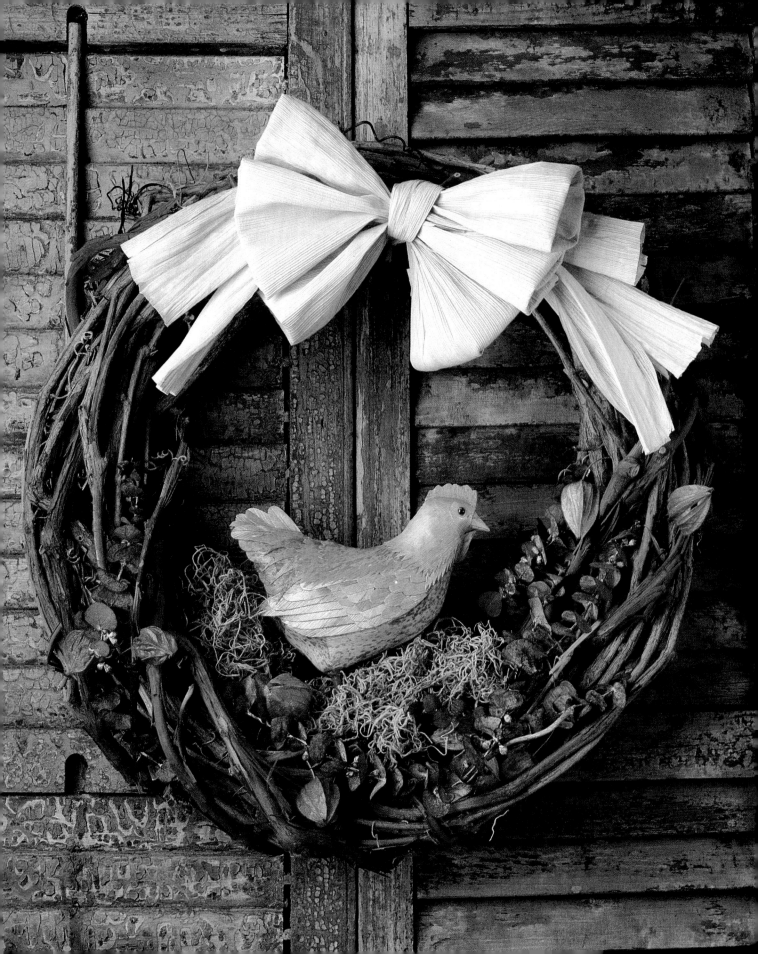

7. For the bow, soak a couple of cornhusks for 20 minutes. Separate the layers and remove excess water with a towel. You will have pieces that are vaguely wedge-shaped. Fold the narrow, pointed end down over the wide edge of the husk. Place a dab of hot glue on one corner of the wide end, and fold over as shown. Press together, taking care not to burn your fingers. (The hot glue may be felt through the thin layers of the cornhusk.) Repeat with 5 other cornhusks to make a total of 6 bow components.

8. While the cornhusks are still damp, assemble the bow. Arrange 6 straight pieces of husk, as illustrated, to make a base for the bow. Next, arrange 3 of the folded husk sections on each side of the base, with ends overlapping in the center. Pick up the base and bow pieces in one hand, with thumb and forefinger holding the bow shape together. With your other hand, wrap the center of the bow with a separate piece of cornhusk.

Turn the bow over and secure with hot glue on the back. While the bow is still damp, run a length of wire through the final loop of cornhusk and tie the bow to the wreath, as illustrated. Use hot glue to reinforce the individual pieces of the bow, remembering to complete gluing and positioning while the bow is still damp. The cornhusk bow will always look soft and graceful, even though its texture is quite crisp.

❧ 8 ❧
Dried Flowers Wreath

BASE straw, 12 inches in diameter

MATERIALS baby's breath, gypsophila, statice, yarrow, silver artemisia, honesty, lamb's ear, strawflowers, love-in-a-mist, santolina, peppergrass, celosia, globe thistle, etc. (3 or 4 clusters of each)

TOOLS hot glue gun, wire pins, floral picks

SIZE 15 inches

INSTRUCTIONS

Note: Because dried flower wreaths are usually assembled according to a set color scheme, the above floral materials suggest just one possible combination of color and texture. Refer to our photos for more specific ideas for color arrangements.

Dried Flowers Wreath (gold)

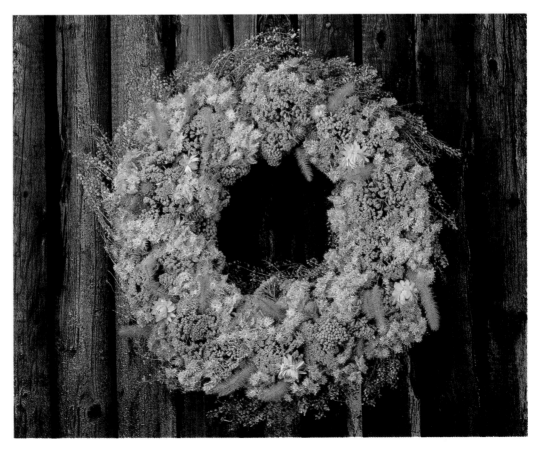

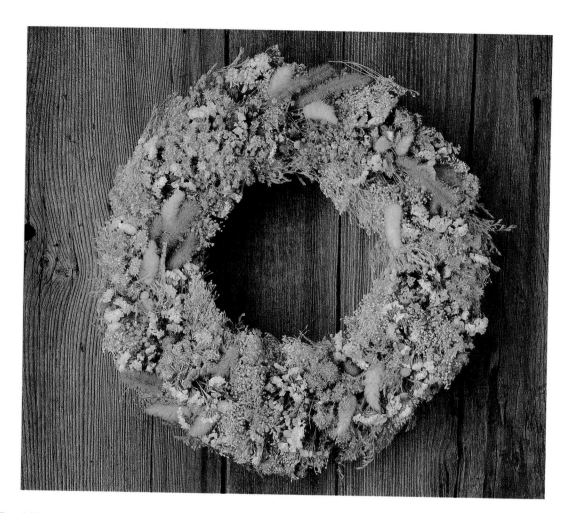

Dried Flowers Wreath (white)

Colors and textures may be selected to reflect a season, to match the colors in a room or the flowers in your garden, and so on. Materials may be used in their natural state, and many commercially dyed materials also are available to support or accent special color schemes.

Our photos illustrate a gold wreath (peppergrass, yarrow, straw-flowers, marigolds, plus assorted wildflowers and plumes), a purple/blue accented wreath (statice, gypsophila, silver artemisia, yarrow, love-in-a-mist, wheat, pussywillows, wheat and strawflowers), and a completely white wreath (baby's breath, gypsophila, statice, and so on). Materials may be attached to the straw base with a glue gun or a combination of wire pins and floral picks. Use whichever method you prefer.

1. First, glue or pin the bulk of your background material around the inner and outer circles of the straw base to lay a foundation for your accent pieces. You can use statice, gypsophila, baby's breath, or any other dried material that completely covers the base. Remem-

Dried Flowers Wreath (purple)

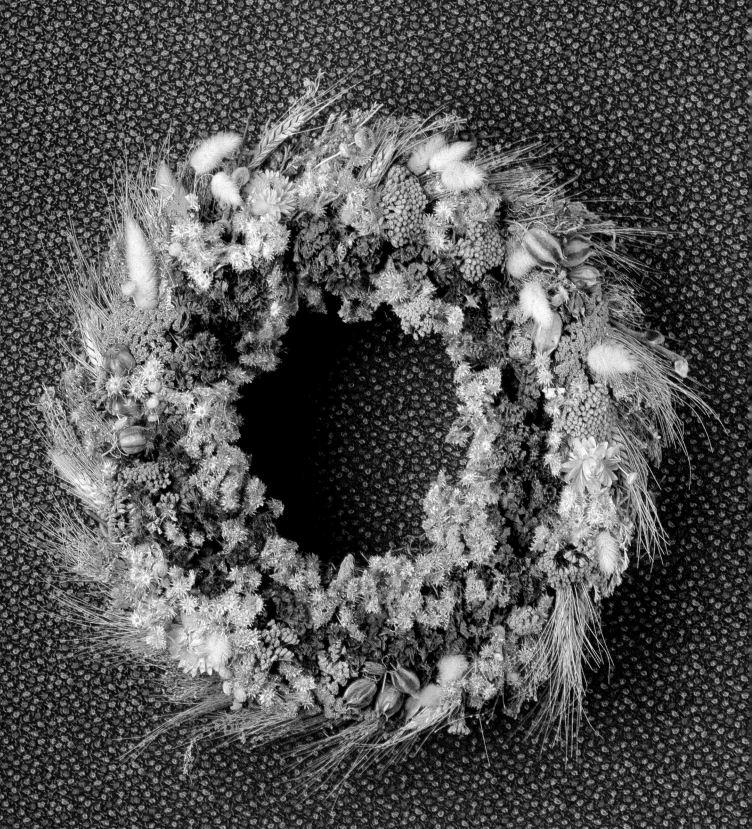

ber that the sides of your wreath will also be visible, so be sure to cover the straw base evenly to the point at which it will rest against the wall.

2. Before you attach the remainder of your materials, experiment with various combinations of color and texture to ensure the most attractive arrangement possible. For example, lacy background material like statice or gypsophila is effectively paired with the bolder blossoms like strawflowers or yarrow, and using smaller flowers in clusters will display them to good advantage against contrasting textures.

3. Attach the accent pieces to the wreath with glue or picks. Then add the final flowers at random for a colorful, old-fashioned effect, or evenly place them around the wreath according to color and texture for a more orderly balance. Either way, aim for fullness and a natural appearance.

❧ 9 ❧
Cornhusk Wreath with Dried Seedpods and Other Materials

BASE straw, 12 inches in diameter

MATERIALS cornhusks (about 1 pound), miniature Indian corn, Chinese lanterns, strawflowers, yarrow, physocarpus

TOOLS hot glue gun, wire floral pins

SIZE 14 inches

INSTRUCTIONS

1. Soak the cornhusks in warm water for 20 minutes.

2. Separate the layers of one cornhusk. Remove excess water with a towel. Each piece will be vaguely wedge-shaped. Select perfect pieces of husk, avoiding any with insect holes. Using one single layer of husk, fold gently in half by bringing the narrow point down to the opposite wide edge (see illustration).

3. Apply a line of glue across the bottom width, as shown (not on the folded edge). Then, being careful not to get burned with the hot glue (you can feel it through the thin cornhusk), firmly but carefully pull the cornhusk into a tight wrap around the wreath. If the cornhusk needs further reinforcement, dot glue into place under any loose flaps on the back.

4. Using a second piece of cornhusk, fold in half as you did with the first. Apply a line of glue across its width; then wrap and press in place on the wreath. Overlap the first piece as desired. The photograph shows a wreath with the cornhusk folds about 2 inches apart. These folds may be closer or further apart depending on how ruffled a texture you wish to create. When dry, the cornhusks will be very crisp and fragile to the touch, so be sure to make all adjustments before the cornhusks are dry. While still wet, turn the wreath over. Using leftover pieces of narrow cornhusk strips, cover the raw edges of the cornhusks. Even though no one will see the back of your wreath, covering the raw edges is a good finishing touch which also conceals the straw base.

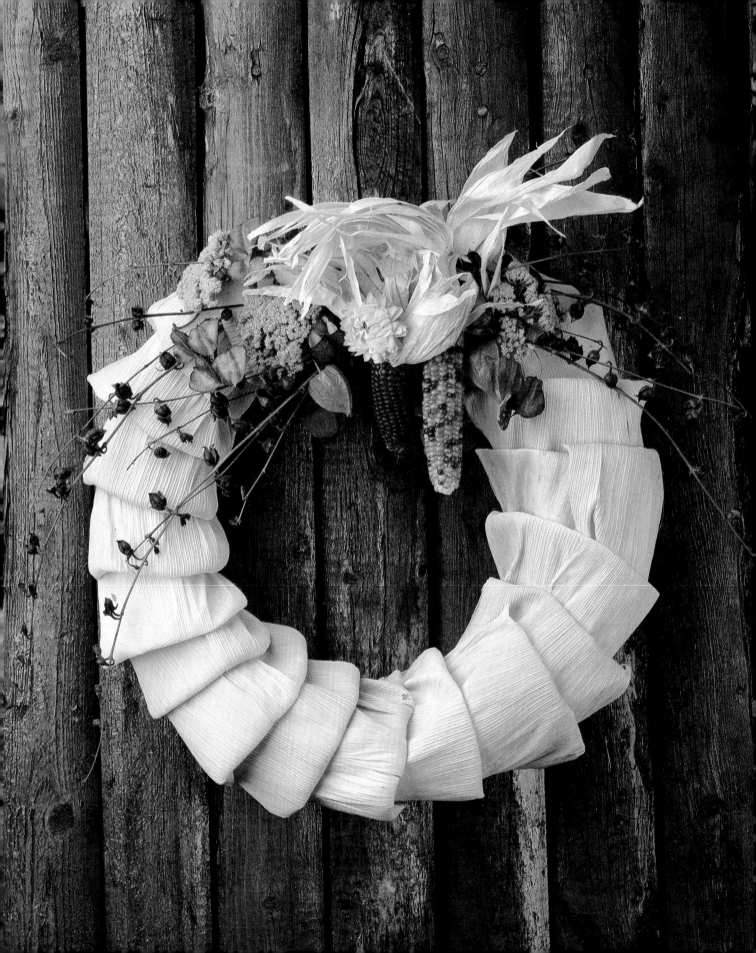

5. Next, place the wreath right side up. Using steel floral pins, attach branches of dried seedpods, physocarpus, Chinese lanterns, yarrow, and strawflowers, as desired, to create a spray of harvest color at the top. Complete the spray by attaching a cluster of miniature Indian corn.

This wreath will last for many years if hung indoors. Out-of-doors, it can safely be hung in a covered porch area—as long as birds don't catch sight of it. Other than birds making a feast of the corn, your only concern is that the wreath not be exposed to dampness and the possibility of mildew.

❦ 10 ❧
Bittersweet Wreath
with Chinese Lanterns

BASE bittersweet vines or grapevine (about 18 yards)
MATERIALS bittersweet, Chinese lanterns (3 or 4 stems)
TOOLS pruning shears
SIZE 12 inches

INSTRUCTIONS

1. Buy a ready-made grapevine wreath of any size to use as a base for this colorful wreath, or, make your own with dried grapevines that have been harvested after the first frost. If you have an especially plentiful supply of bittersweet, you may wind a wreath completely of bittersweet and not use grapevines at all. Grapevines are generally long and flexible, lending themselves easily to use in a wreath. Bittersweet, on the other hand, tends to be short-stemmed and multi-branching. By combining these 2 materials, each can be used to its best advantage.

2. Coil the grapevines into an even, circular shape by winding them around the base of a bucket. When you have ⅔ of its bulk in place, slide the wreath off the bucket and wind the final wraps, in and out, around and around the wreath, tying it together. You may work only in 1 direction or wind in reverse for the final round, creating a zigzag pattern in the design. Because grapevine is so strong, it is easy to experiment with different methods. You can take your first attempt apart and try again if you wish.

3. Add the bittersweet to the grapevine base by weaving pieces of it into the wreath in random fashion all around the circumference. The lacy texture of bittersweet contrasts nicely with the sturdy grapevines. As you work, be careful not to pull the red/orange seeds off the vine.

4. To finish, tuck in a cascade of Chinese lantern seedpods for a colorful bow-like trim.

This wreath is perfect for use outdoors, where the cool Fall weather will keep the bittersweet looking fresh for quite a long while. Indoor heat tends to shrivel and dry the berries.

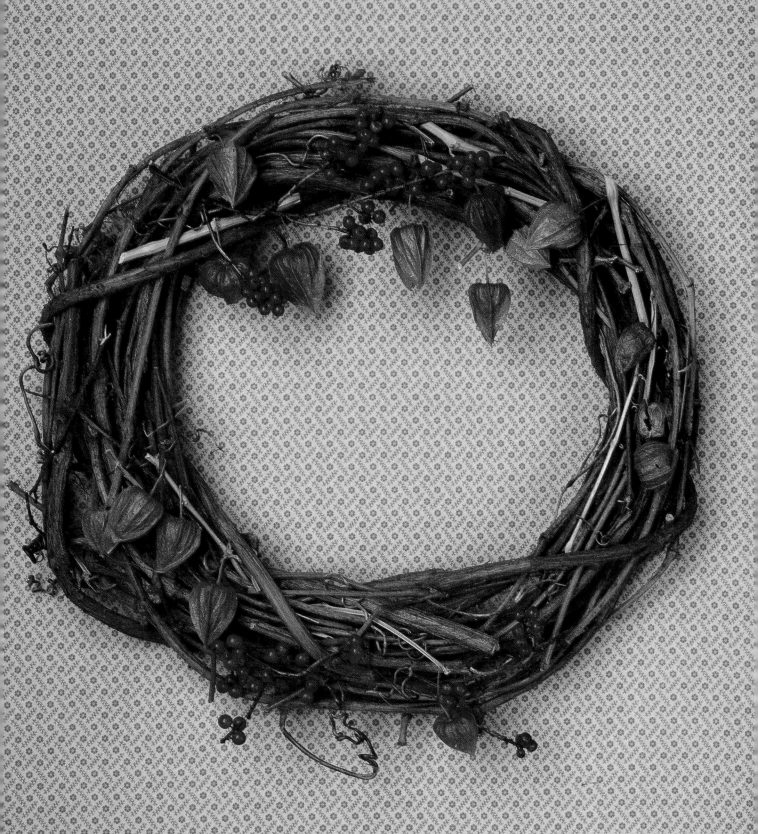

❧ 11 ❧
Shells and Sea Harvest Wreath

BASE straw, 12 inches in diameter

MATERIALS seashells, coral bits, small pieces of driftwood, and other natural materials found while beachcombing. (A large supply will provide many options to complete your final design.)

BOW MATERIALS starfish

TOOLS hot glue gun

SIZE 13 inches

INSTRUCTIONS

1. First, sort your shells by size: small, medium, and large. To provide a unified background, this wreath uses Van Hyning's cockles and strawberry cockles. The large variety of small shells—cone shapes, spirals, disks, and so on—glued into all the odd spaces add texture and visual interest. Nassas, limas, doves, augers, olives, limpets, venus, scotch bonnets, tritons, nutmegs, ceriths, and whatever else you might have from a trip to the shore, will surely enhance the appearance of your wreath.

2. Begin by gluing the large shells around the top surface of the wreath. Apply glue around the edges of each shell with the glue gun, and then press the shell into place. Hold firmly for about 30 seconds to ensure a solid bond.

3. Next, glue large shells around the outside of the base. Finally, add large shells to the inner circle of the base. Any specially prized shells may be added at this time as focal points.

4. Next, use medium-sized shells to begin to fill in the spaces on the top of the wreath. Repeat on the outer and inner circles of the base.

5. With the large and medium shells now attached to the base, you will have lots of nooks and crannies to fill with small shells and small pieces of other beachcombing treasures. Coral bits, for example, may be glued onto the large or medium shells however you wish.

6. To complete this wreath, a starfish was added as a kind of nautical bow.

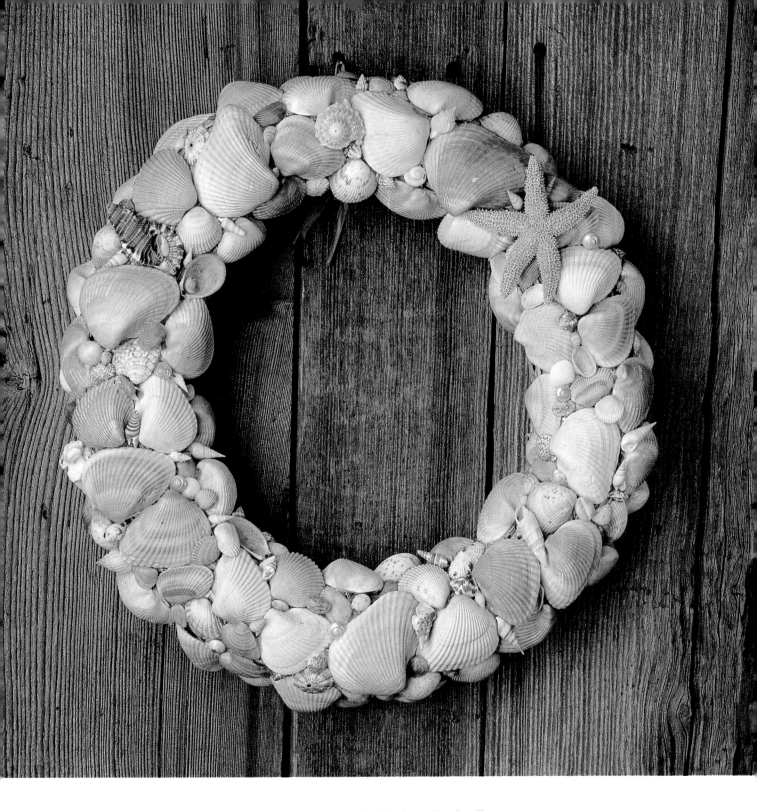

7. Make a sturdy hanging loop by threading a double length of raffia or string through the back of the straw, and knot securely. This wreath may be displayed year-round or used as a special holiday wreath.

❧ *12* ❧
Valentine Eucalyptus Wreath

BASE pre-formed, 3-dimensional wire heart, 12 inches in diameter

MATERIALS eucalyptus, white baby's breath or statice

BOW MATERIALS red satin ribbon (about 3 yards)

TOOLS hot glue gun

SIZE 13 inches

INSTRUCTIONS

1. Divide your eucalyptus stems into two groups, long and short. Small, multi-branching sections can be used just as they are.

2. Using the longest pieces first, weave the eucalyptus into the wire wreath, taking care not to have any pieces end on the outside curves of the heart. Try to place the stem ends either at the center "V" or the bottom "V" of the heart. This will keep the heart shape smooth and rounded.

3. Continue to fill in the entire shape of the wire wreath, using all of the longest pieces first. If needed, reinforce the wreath by gluing some stems to each other with clear hot glue. Always hide the stem ends under the foliage of other pieces.

4. Using the smallest pieces last, tuck them into whatever bare spots are left. Once again, reinforce with glue if necessary.

5. Make 2 tiny bouquets of white statice or baby's breath. Place them, stem ends together, blossoms facing outward, as illustrated, on the right side of the heart. Using red satin ribbon, fasten the tiny bouquets to the wreath and tie a simple bow.

6. A hanging loop can be made from red satin ribbon tied to the center "V" of the wreath. Or, a hidden, hanging loop of wire, string, or raffia may be concealed behind the eucalyptus.

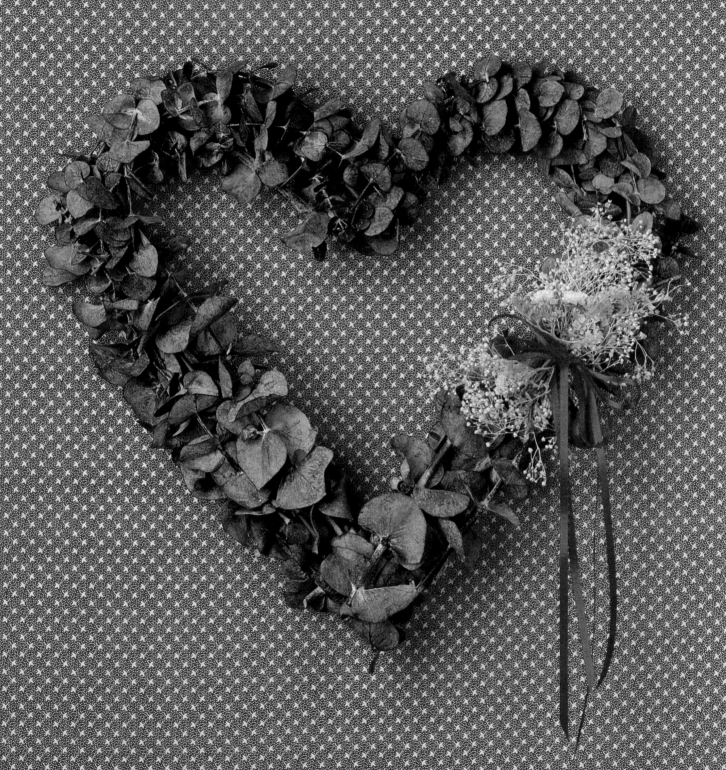

❧ 13 ☙
Herbal Display Wreath

BASE straw, 12 inches in diameter

MATERIALS culinary and medicinal herbs and spices—about 15 pieces each of basil, oregano, cinnamon sticks, bee balm seedpods, lamb's ear, sage, anise, silver artemisia, dill, dried chive blossoms, and enough bay leaves to cover the inner and outer circle of the straw base

TOOLS hot glue gun, wire pins, floral picks

SIZE 14 inches

INSTRUCTIONS

1. Although some pieces are attached individually, most of the herbs in this wreath are attached to the base in clusters. To make a foundation for these clusters, it is traditional to use a circle of bay leaves. Bay leaves may be purchased most economically in bulk at health food stores. With a hot glue gun, glue the individual leaves in an overlapping circle around the outside of the wreath. To overlap, place a dab of hot glue at the bottom end of a leaf and press in place. Continue in the same manner, with the remaining bay leaves, placing each leaf slightly beyond the next one to produce a graceful, rippling effect. Repeat with an overlapping ring of bay around the inner circle of the wreath.

2. Depending upon how many you plan to use, divide your herbs into 5 or 7 groups of each herb variety. The clusters will be evenly spaced around the wreath.

3. Divide the wreath base into 5 or 7 sections and insert 5 or 7 pieces of floral wire into the straw base to mark the spatial divisions of the design. The wire serves as a guide and doesn't have to be removed until the wreath is complete.

4. With the bay leaves in place, decide how you wish to join the rest of the herbs to the base. They either can be glued with the hot glue gun, pinned in place with "U"-shaped wire floral pins, or attached with floral "picks." Glue works best for smaller pieces or fragile herbs. Wire pins are handy for herbs with sturdy stems (like artemisia), and floral picks—green wooden picks with a wire attached—

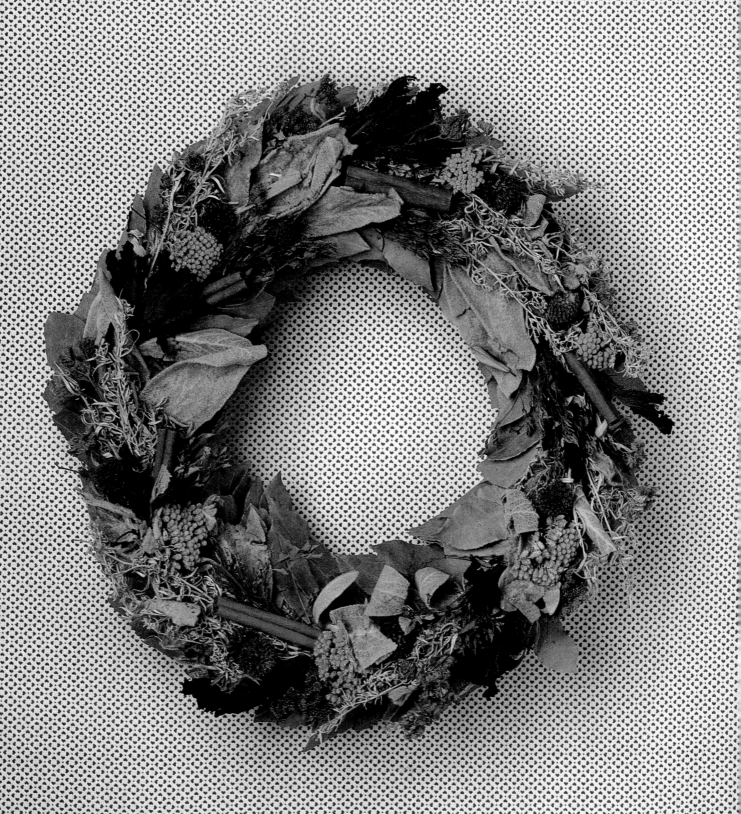

are best for making small clusters of accent herbs. Just gather together a few sprigs of oregano, for example, and wrap the stems with wire.

5. Prepare all of the floral picks with accenting herb clusters.

6. Set aside the sturdy herbs—artemisia, dill, and sage—that will be pinned.

7. Set aside the small, fragile herbs that will be attached with glue as a final step.

8. You are now ready to finish assembling the wreath. Taking the herb you have the most of—silver artemisia, for example—attach to the base with wire pins an equal amount in each of the predetermined sections. Be careful to keep the clusters equidistant so that their texture and color will contribute effectively to the overall design of the wreath.

9. Pin, pick, or glue the clusters or leaves of your next herb into place. Lamb's ear leaves, for example, which should be used when they are fresh and not dry and brittle, may be glued individually by their stems. When adding herbs to each of the predetermined sections of the wreath, be sure to insert them at the same spot in each of the 5 or 7 spaces. The cinnamon sticks, for example, are glued to the center of the unit space, and all of the silver artemisia is in the outer perimeter of each space. By proceeding in this manner, you will give style and symmetry to your wreath. The irregular edges of your material will offset the straight lines of the predetermined sections to produce a pleasing overall effect.

10. Proceed with the rest of your materials until the base is completely covered. The last items to be added should be single items—anise stars, cinnamon sticks, garlic bulbs, or single bee balm blossoms—that are inserted as accent pieces.

❧ 14 ❧
Dried Grasses, Ferns, Flowerheads, and Seedpods Wreath

BASE straw

MATERIALS assorted varieties of dried grasses, ferns, flowers, and seedpods—gathered from roadsides after frost. Most will be shades of brown—but *so many shades* of brown (about 3 shopping bags full)

TOOLS hot glue gun, wire pins, floral picks

SIZE 18 inches

INSTRUCTIONS

1. This wreath is composed totally of roadside materials, which, when viewed individually, are often thought of as mere weeds. However, when their textures and colors are combined in a wreath they make a stunning composition of nature's end-of-season glory.

Gather your dried materials and discard any with insect damage, spider webs, or egg casings. Then decide which types and materials are best suited for each assembly method.

2. Flowerheads or seedpods without foliage are best joined into clusters with a floral pick. Trim the stems of 5 dried bee balm blossoms, or black-eyed Susan heads, or whatever else you have, to a uniform 3-inch length, and twist together on a floral pick. These miniature bouquets will display the plants' characteristic features which might be overlooked if these materials were positioned individually.

3. Larger background pieces, such as sprays of sturdy seedpods or dried ferns, are best joined in bunches with wire "U" pins.

4. Hot glue can be used for anything that isn't adaptable to the use of wires and picks. Weathered hickory nut husks and sweet gum balls fall into this category.

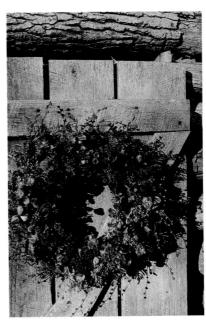

Dried Grasses, Ferns, Flowerheads, and Seedpods Wreath

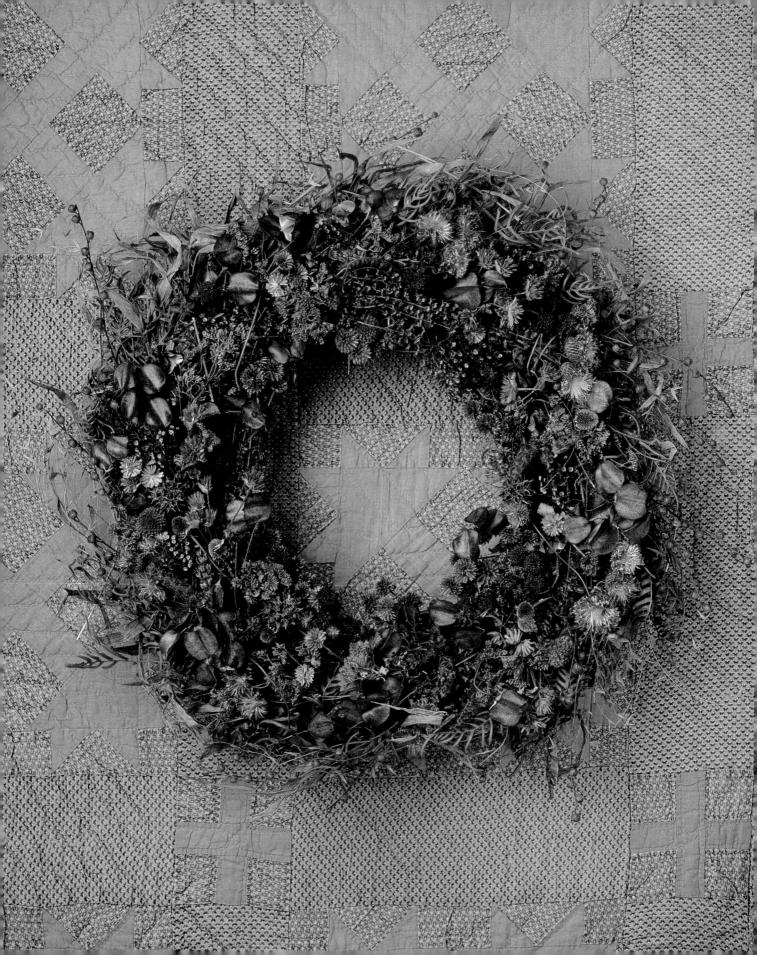

5. This wreath is most effective when a large variety of materials is used. You can incorporate 10 or even 20 different kinds of dried flowerheads, seedpods, and grasses. With your materials organized into bunches, clusters, or individual pieces, you are ready to assemble your wreath. Begin by pinning on an outside border, using only one type of material—dried ferns, for instance. This outside circle will be closest to the wall when the wreath is hung, and its foliage will provide the background for your other materials.

6. Next, attach a second layer, using a different foliage above the first.

7. Attach an inner circle of complementary foliage on the inside rim of the straw base. This circle will also rest close to the wall when the wreath is hung, and the tips of its foliage will be silhouetted against the wall.

8. Finally, fill in the rest of the wreath, using 1 material at a time, spacing each kind of material evenly around the circle, and completely covering the straw base. Though you'll be assembling the wreath with a set plan, you'll use different quantities of each type of material, and thus, the finished wreath will retain the natural look of the autumn roadsides.

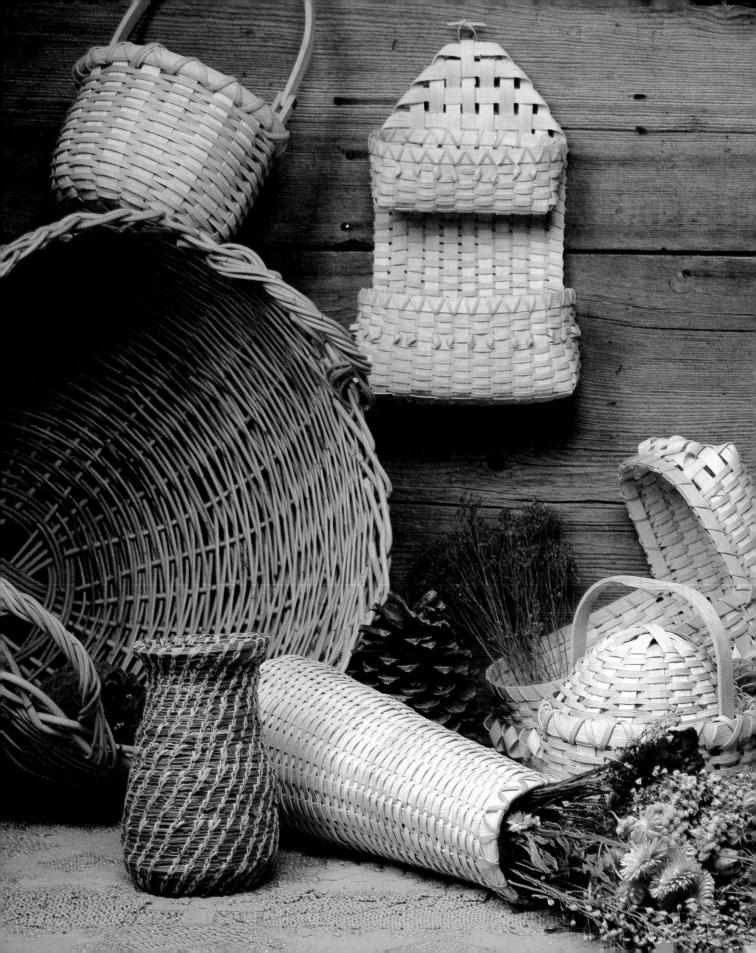

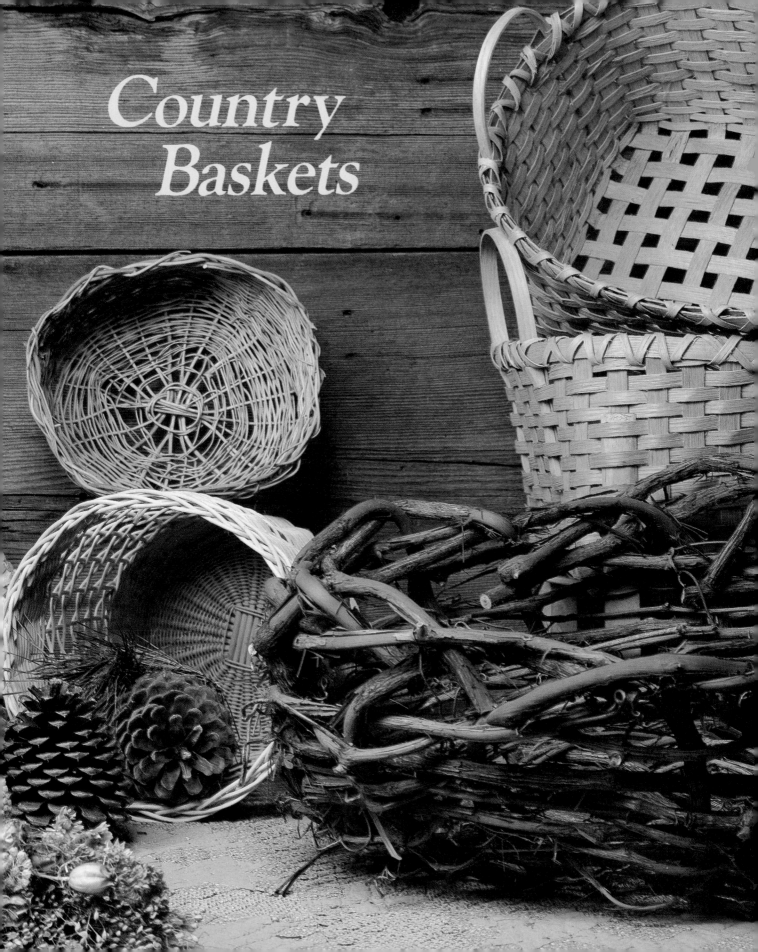

Country Baskets

❧ Introduction to Baskets ❧

Those of us who make baskets belong by means of this art to the world's earliest kind of craftsmen. Basket-making was without doubt primitive man's first applied skill, older by far than pottery-making or even the chipping of stone tools. However, because of their fragile nature, few of these containers have survived, and those which have survived date from a relatively later period.

But "lateness" too is relative, for the earliest known basket fragments are over 9,000 years old! These were found at Danger Cave, Utah, and were the most ancient of an impressive series of finds which defined a whole culture of native Americans. These people, known to us as the Basketmakers, lived and worked in the area where the present-day borders of Arizona, Colorado, New Mexico, and Utah converge. During a period roughly between 800 B.C. and 700 A.D., they turned out an impressive variety of finely crafted basketry objects. Among those discovered by archaeologists are coiled and twined storage, eating and burden baskets, cord made from hemp and human hair, woven sandals and mats, and even large baskets in which children were buried. All were preserved by the remarkably dry climate.

North America is not the only place where ancient basketry was made. Peruvian graves from the period 2,500–1,250 B.C. have yielded small woven grass and rush boxes used to hold weaving tools, and baskets of comparable age have been discovered in China, Egypt, and the Near East.

This is hardly surprising, for early man was primarily nomadic, and containers in which to carry and store food were a necessity. At first, these were probably made from large leaves or animal skins, but the practicality of basketry made its development inevitable. Moreover, the connection of baskets with the storage of vital food grains is evident in religious observances such as the basket dances, known not only in North and South America, but also in medieval Germany and Eastern Europe. Typically, these involved women who strew seeds from a basket, thus symbolizing spring planting and seeking the assurance of the gods of a good crop.

The first Europeans to settle in what is now the United States brought with them highly advanced basket-making skills. Splint and, particularly, willow basketry had reached a high level in Europe during the Middle Ages, and in 1569 a basketry company or guild was established in London. This guild adopted the rules and traditions of better known groups, such as the silver- and pew-

ter-makers' guilds. Maintenance of standards (and a little market control!) was the guild's goal, and it had the power to seize and burn baskets deemed not up to standard.

This pride in workmanship has continued among basket-makers both professional and amateur. Rivalry over form and construction was often openly expressed, as in the case of the fourth generation craftsman, Mrs. Ray Seavey of South Berwick, Maine, who told the following tale to Allen H. Eaton at the time he was writing his *Handicrafts of New England*:

> One time I was talking with a basket-maker up on Great Hill, and I said, 'Here is my basket, you show me yours, and I'll let you jump on mine upside down, but if I just stand on yours it will fall in.' Well, he wouldn't let me do it—just goes to show. You take a basket made our way and put it between your knees and you can't budge it no matter how hard you squeeze. Most any other basket will squeeze flat and not come out again.

Willow traveling case, New England, c. 1860–1890. Willow suitcases were lighter than those made of leather and remarkably strong. Some were made in this country; others were brought from Europe by immigrants.

Early 20th-century mountain craftsmen were particularly proud of their handiwork. One crusty Appalachian maker, when asked by a young tourist how sturdy the basket he sold her really was, replied, ". . . it will outlast you, marm;" while Mitchell ("Mitchy") Ray, a famous Nantucket basket manufacturer of the 1930's and 1940's even put a label on some of his baskets which boasted that "I was made in Nantucket, I'm strong and stout/Don't lose me or burn me, and I'll never wear out."

Indeed, many of these fine old baskets were exceptionally well made. Another fourth generation basket-maker, Clarence Baggett of the Arkansas Ozarks, owned a white oak rib basket made by his grandfather which, after 50 years, would still carry a peck of rocks. Nor was strength the only desirable characteristic. In 1903 Jennie Hill, in the *Southern Workman*, noted that "it is the boast of some of the most skillful old basket-makers that their baskets will hold water, and it is an actual fact that they are sometimes so closely woven that meal can be carried in them."

These standards have been maintained by contemporary craftsmen. Lucy Cody Cook, who with her husband, William, served as craft demonstrator at Colonial Williamsburg between 1967–1972, has stated flatly that "(t)here is no shortcut for making a good basket."

Left: Splint market or produce basket, New England, c. 1860–1900. Right: Splint gathering basket, New Jersey, c. 1890–1910. A wide variety of baskets were used in harvesting, transporting, and storing of garden products.

While, as previously mentioned, native Americans have been producing baskets in North America for thousands of years, it is not known when the first colonial baskets appeared. It is likely, though, that they were almost simultaneous with initial settlement. It was customary in the colonies to take an inventory of the estate of each adult who died, and these documents indicate that baskets were common in settlers' homes. There is reference to a "Child Bed Basket" (cradle) in the inventory of the Reverend Ebenezer Thayer, who died in Roxbury, Massachusetts, in 1732; while John Buttolph, who died in Wethersfield, Connecticut, in 1692, left behind two half-bushel field baskets. Other records include a "willow basket" in the estate of Daniel Fisher of Dedham, Massachusetts, deceased in 1683, and a wicker cradle owned at his death in 1691 by John Bowles of Roxbury, Massachusetts.

Small splint carrying-basket of the rib construction type, Appalachian Mountains regions, c. 1890–1920. These containers came in several sizes and might be used for anything from eggs to potatoes.

Basket-makers (with notable exception of the men who made the Nantucket, Massachusetts, examples) rarely signed their work, and, as artisans of modest means, they seldom advertised or came to public notice. Yet, the important part they played in our economy well into the 20th century is reflected not only in the quantity of their work which has survived, but also in place names, which indicate a once flourishing industry.

Thus, the community of Basket in Bucks County, Pennsylvania, memorializes the role of Reuben Reifsnyder, a veteran soldier and basket-maker who settled there after the Civil War, continuing to work into the 1880's. And, Basket Street, a road in the vicinity of Sandwich, New Hampshire, was once lined with the homes and shops of artisans.

Indeed, it seems likely that it was more the rule than the exception for basket-makers to settle in close proximity to each other. One of the largest 19th-century centers was at Liverpool, near Syracuse, New York. The first craftsman to work there, around 1850, was John Fisher. He was drawn by the abundant stands of native willow. By the 1890's, however, these had been supplemented by groves of imported Caspian and Purple Willow, and nearly 2,000 people were involved in what had become a major industry, producing upwards of 400,000 individual items per year. The Liverpool industry flourished through the 1920's, and the last commercial manufacturer did not shut down until 1960.

Of course, most basket-making was carried on by a single individual or by a small group of people, often related. An interesting example of the latter is found in the Pound Ridge-Dantown area along the New York-Connecticut border. In 1841, the basket-

maker Sands Selleck established a small manufactory at Scotts Corners in the town of Pound Ridge, Westchester County, New York. Gradually the business spread to neighboring Dantown, Connecticut, a community now beneath the waters of Laurel Reservoir.

By the 1880's, several dozen families, often closely related, were involved in the trade. The area was commonly referred to as "Basket Town," and baskets served almost as a form of legal tender within a fifty-mile radius. Unlike the case at Liverpool, where dozens of different forms of basketry, from hampers to carriage bodies, were made, the Pound Ridge and Dantown craftsmen concentrated primarily on clam and fish baskets, sturdy splint receptacles with openwork bottoms to allow for water drainage, which were sold to clammers and fishermen up and down Long Island Sound and the Hudson River. Though much reduced after 1900, the business survived until about 1920. One of the last of the old-timers was Sivori Selleck, who died in 1936.

Few of these basket-makers became rich at their trades. Baskets sold for, at best, a dollar or so apiece, and long hours were consumed not only in the making of the baskets but in the preparation of materials. Still, some managed a living. In his *Handicrafts of the Southern Highlands*, Allen H. Eaton describes a famous black basket-maker, Levi Eye (d. 1926), of Pendleton County, West Virginia.

> Mr. Eye had a family of sixteen, including parents, which he maintained by making and selling baskets . . . He would barter his baskets for lard, meat, flower, or whatever was needed . . . I asked him how many baskets he had made in his long lifetime and he said, 'Well, I was just the other day figuring on the number and I made it a little over 7,000 . . .'

Eye's life must have been very similar to that of Lela Solomon, a Choctaw Indian from Mississippi, who, in the catalog to an exhibition of her work prepared in 1971, described her family's involvement in the craft:

When I was growing up, basket-making was a real family affair among the Choctaws. During the winter months, Mother and Dad, with the children helping, would make all kinds of baskets, enough to fill a wagon. When summer came, the family would load up a wagon, pulled by a team of mules or steers, and travel around the country, for as long as a month at a time, trading baskets for most anything we could get; food, clothing, quilts and sometimes we would sell a basket for twenty-five cents. That was the family's spending money . . .

Fortunately, few of us today must count on basketry for anything more than the pleasure of relaxation and the satisfaction that comes from a job well done. Perhaps these benefits were best expressed by George W. James in his 1916 book *Practical Basket-making*, when he noted that ". . . the basket-weaver will stimulate her own mental activity; her powers of observation will be quickened, aroused, and strengthened; her reflective powers will be heightened, and . . . she will find her spiritual nature thus quickened into a higher and fuller life . . ."

Handled splint field or produce basket in old salmon paint, Maine, c. 1860–1880. Note the round top and square bottom—a refinement in technique not all basket-makers could master.

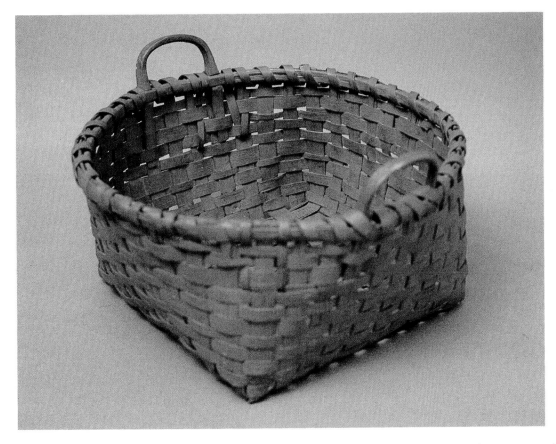

❧ 1 ❧
Miniature Rectangular Basket

SHAPE rectangular base, oval top

MATERIALS ³/₁₆-inch flat reed, ¼-inch flat oval reed, medium cane (1 strand each)

SIZE 2½ inches long × 1½ inches wide × 2½ inches high without handles

INSTRUCTIONS

1. Soak the reeds (see page 17). Cut 3 pieces of wet ³/₁₆-inch flat reed splints, each 5½ inches long. Cut 5 pieces of wet ³/₁₆-inch flat reed splints 4½ inches long. These are your spokes. Cut 2 pieces of ¼-inch flat oval reed 5½ inches long. These materials are for the handle and should be kept in water while you weave the basket. An additional strand of flat oval reed should be soaked as well; it will be cut to fit for the top border bands. Wind 3 short strands of medium cane into coils and soak: 2 of these will be used for weaving and 1 for the border lashing.

2. Lay out the base of the basket, using the ³/₁₆-inch flat reed spokes as shown in Figure 1a. The base should measure 1¼ inches × 2 inches. Weave a length of string or raffia over and under the entire perimeter of the spokes to secure the pattern for weaving. Tie a knot, and trim the ends of the string.

3. Tuck a wet weaver of medium cane into the corner, using a clip clothespin to hold it in place. Keep the shiny side (bark side) of the cane on the outside of the basket. Placing your hands on the outside of the basket, with the spoke ends pointing away from you, bend up the sides of the basket as you weave over—under—over—under along the side (Figure 1b).

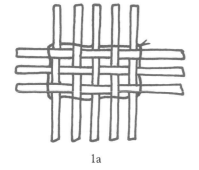

1a

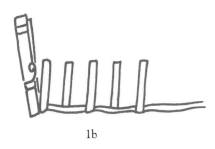

1b

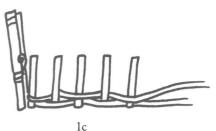

1c

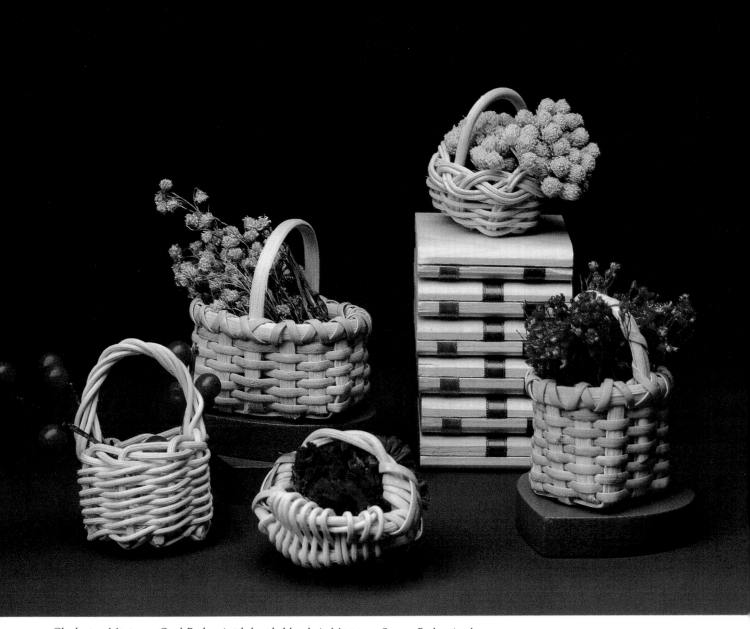

Clockwise: Miniature Oval Basket (with braided border); Miniature Square Basket (with round top); Miniature Melon Basket (with Eye-of-God end patterns); Miniature Round Basket (with twisted handle); Miniature Rectangular Basket.

4. With one side woven, take your second cane weaver, and tuck it into the same corner as the first weaver. Now use it to weave a second row above the first, thus using two weavers to make the plain-weave pattern (Figure 1c). Plain-weave requires an odd number of spokes. Normally, one would either split one of the spokes to achieve the odd number or insert an additional spoke. However, with miniature baskets, this is not only difficult to manipulate but can result in a lopsided basket.

The most successful method is to weave over an even number of spokes with two weavers simultaneously: one weaver weaves all of the "overs" and the second weaver weaves all of the "unders." A balanced plain-weave is achieved and to all appearances, the basket has been woven with one weaver.

5. Continue with the plain-weave for a total of 8 rows—(about 1 inch high). Be sure to keep the spokes upright to establish the form of the basket from the outset. It will take 3 or 4 rounds to establish an even shape, so continue to use the clothespin as a third hand, whenever needed.

After each round, gently pull the weavers to adjust the tension. The rows should be smooth and close together (Figure 1d). Spokes should be positioned at a right angle to the base. If you pull too tightly, the basket will taper in at the top; if you weave too loosely, the basket will flare out irregularly. Ideally, a graceful oval shape should result at the top of the basket. This is characteristic of rectangular-based baskets woven with flat splints.

6. You are now ready to insert the handle pieces—2 layers of flat oval reed. Tuck one 5½-inch long piece of ¼-inch flat oval into the weaving at the center spoke. Keeping the flat side of the reed towards the basket, slide the end of the reed into the weaving on the inside of the basket, bringing the end to rest near the bottom of the basket. Then, tuck the opposite end of the handle into the opposite side of the basket, and also on the inside of the basket (Figure 1e).

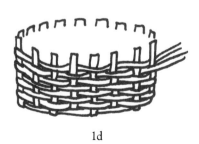

1d

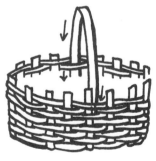

1e

7. Next, tuck the second 5½-inch long piece of flat oval into the weaving at the center spoke, but this time, slide the end of the reed into the weaving on the outside of the basket. The center spoke of the basket will be sandwiched between the two handle pieces. The flat side of the reed should face the basket. As before, slide the handle down towards the bottom of the basket, and repeat with the second side. You now have a double layer handle (Figure 1f).

8. The basket rim is made up of 2 bands: 1 on the inside and 1 on the outside of the basket. To attach the rim to the basket, measure a piece of wet, flat oval reed for the outside band. Allow a ½-inch length of extra flat oval to overlap the band ends. Measure a second flat oval band to fit the inside measurement of the basket, also with a ½-inch overlap. (The inside diameter of a basket is smaller than the outside diameter.)

Keeping the flat sides of the reed towards the basket spokes, clip the bands onto the basket with 2 clip clothespins. Position the overlapping ends at the handle, and the inside overlapping ends on the opposite side of the basket from the outside overlapping ends. This will avoid having an unbalanced amount of bulk on one side of the basket (Figure 1g).

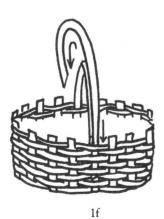

1f

1g

1h

1i

9. If necessary, trim the spoke tops with a pair of scissors to make them flush with the top of the rim. The spoke ends will go right up to the top of the rim, but they should not stick out.

10. To lash on the border, tuck an end of medium cane under the border and bring it up and around the bands. Lash from left to right around the basket, maintaining a firm and even tension (Figure 1h). Keep the bark side on the outside of the basket, and be sure that the cane does not become twisted.

11. After one round, reverse, and lash in the opposite direction to complete a zigzag pattern around the basket. At the handle ends, lash an "X" instead of zigzag. To complete, tuck the cane tightly into the weaving and trim the end (Figure 1i). Snip the guide-string, and remove it from the bottom of the basket.

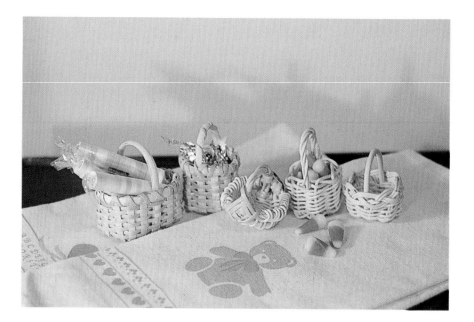

Miniature Baskets

Miniature Square Basket

SHAPE square base, round top

MATERIALS ³⁄₁₆-inch flat reed, ¼-inch flat oval reed, medium cane (1 strand each)

SIZE 1½ inches in diameter, 2½ inches high

INSTRUCTIONS

1. Cut 6 pieces of wet ³⁄₁₆-inch flat reed splints, each 5 inches long. These are your spokes. Cut 2 pieces of ¼-inch flat oval reed, each 5 inches long. These reeds will be used for the handle and should be kept in water while you weave the basket. An additional strand of flat oval reed should be soaked as well for use as the top border bands. Wind 3 short strands of medium cane into coils and soak. Two will be used for weaving and 1 for the border lashing.

2. Lay out the base of the basket, placing the ³⁄₁₆-inch flat reed spokes as shown in Figure 2a. The base should measure 1¼ inches square. Weave a length of string or raffia over and under the entire perimeter of the spokes to secure the pattern for weaving. Tie a knot, and trim ends of string.

3. Insert 2 cane weavers, as in the previous rectangular splint miniature (page 68), and weave the basket in plain-weave for 10 rows (1¼ inches tall).

4. Complete the basket with a flat oval reed handle and cane lashing as described in instructions for previous rectangular splint miniature (page 72). If you wish, on the second round of rim lashing, wind the handle with cane, and finish by tucking the cane tightly into the weaving (Figure 2b). Trim the cane end. Snip the guide-string, and remove it from the bottom of the basket.

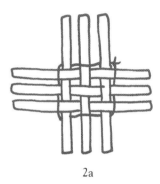

2a

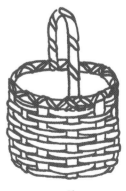

2b

Miniature Melon Basket

SHAPE oval rib with Eye-of-God end patterns

MATERIALS #6 round reed (1 strand), #4 round reed (1 strand), #1 round reed (2 strands), medium cane (1 strand)

SIZE 2 inches in diameter, 2 inches high without handle

INSTRUCTIONS

1. Cut 2 pieces of the wet #4 round reed, each 11 inches long. These will be coiled into the handle and rim bands of the basket. Cut 2 pieces of wet #6 round reed, each 2½ inches long. These are the ribs of the basket. Cut the ribs at an angle so the spokes will be pointed and easier to insert into the basket. Cut a strand of medium cane into 2 lengths; you'll need approximately 27 inches of cane for each Eye-of-God pattern. Do not cut the #1 round reed. You'll need 1 or 2 strands for use as weavers. Keep all the fibers in water until you need them.

2. Wind the #4 round reed into 2 coiled circles 1½ inches in diameter (Figure 3a).

3. Place the 2 circles within each other at right angles (Figure 3b). For easier comprehension, the remaining illustrations will show these coiled hoops as simple circles.

3a

3b

4. Take a strand of wet cane, and place an end under the cross. Cross over the center and bring the reed around "A" to secure the end (Figure 3c).

5. Cross and wrap around "B," as shown in Figure 3d.

6. Cross and wrap around "C," as shown in Figure 3e.

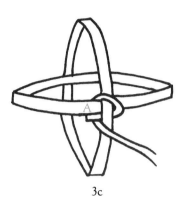

3c

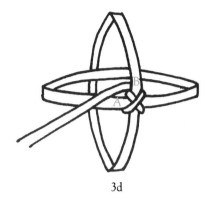

3d

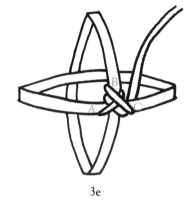

3e

7. Cross and wrap around "D," as shown in Figure 3f.

8. Repeat steps 4 through 7 for 4 rounds, as shown. Place each row of cane wrapping next to the previous row to create an even pattern. If you lose track of the number of rounds you have made, simply count the loops on the back of the cross to determine how many times you have gone around. Insert the end of the cane into the Eye-of-God pattern and pull to tighten. Trim end. Figures 3g and 3h illustrate the completed Eye-of-God from the front and back. Repeat this pattern on the second side of the crossed circles with the other piece of cane.

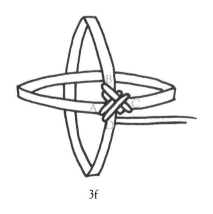

3f

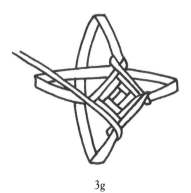

3g

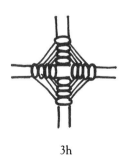

3h

9. You are now ready to weave the body of the basket. Insert the two #6 spokes by placing each one behind the crosses from one side to the other. The ends will lie in place behind the crosses; they should not tuck into the Eye-of-God pattern. The pressure on the ends will hold them in place until you have woven the basket (Figure 3i).

10. Hold the basket with the handle down towards your lap and the ribs of the basket facing upwards. Insert a wet strand of #1 round reed and weave over—under—over—under (plain-weave) back and forth around the bottom of the basket. The 2 ribs and 3 coiled sections provide 5 spokes to weave on (Figure 3j). Keep the rows close together, and work towards a smooth, rounded shape. You should not be able to see spaces between the rows.

11. Because this basket is small, one weaver may be all you need to weave across the entire bottom. However, if you need a second strand, just tuck it into the weaving and continue. When you reach the second Eye-of-God, trim the end of the #1 weaver and tuck back into the basket (Figure 3k).

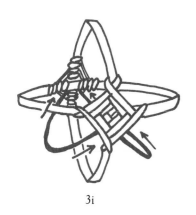

3i

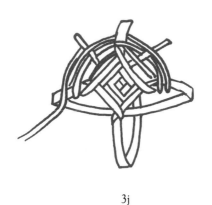

3j

3k

❧ 4 ❧
Miniature Oval Basket

SHAPE oval with braided border

MATERIALS #1 round reed (2 strands), #6 round reed (1 strand)

SIZE 1¾ inches in diameter, 2 inches high

INSTRUCTIONS

1. Cut 8 pieces of wet #1 round reed, each 9½ inches long. These will be your spokes. Cut 1 piece of #6 round reed 4 inches long. This will be your handle. One additional strand of #1 will be needed to be used as a weaver. Keep all materials in water until ready to use.

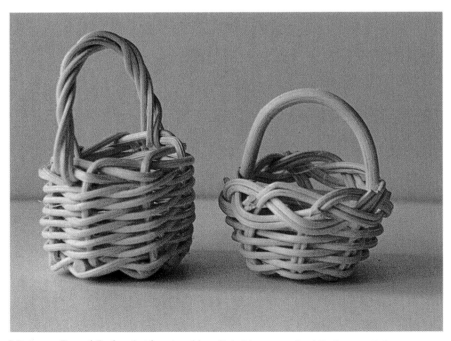

Miniature Round Basket (with twisted handle); Miniature Oval Basket (with braided border)

2. Lay out the base of the basket, using the #1 spokes as shown in Figure 4a. The spokes will be doubled up, so that 8 spokes will actually provide 4 sets. With a piece of string or raffia, to secure the pairs of spokes by weaving over and under the pairs, as shown. Trim the ends of the string. The secured base should measure about ⅝ inch × 1 inch.

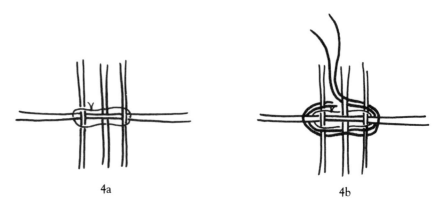

4a 4b

3. Cut your strand of #1 weaver into 2 lengths. Tuck the first one into the weaving, and weave 1 round over and under the pairs of spokes, following the path of the guide-string. Then, add the second length of #1 and weave a second round, over and under the pairs of spokes, thus, using 2 weavers to weave a plain-weave pattern. Plain-weave requires an odd number of spokes. Normally, one would add an additional pair of spokes to achieve the odd number. However, with miniature baskets, this is not only difficult to manipulate, but can result in a lopsided basket. Therefore, the most successful procedure is to weave over an even number of spoke sets with 2 weavers simultaneously: one weaver weaves all the "overs," and the second weaver weaves all the "unders" (Figure 4b).

4. Weave a total of 10 rounds with the #1. Beginning with the third round, bend the spokes upright, pointing them away from you. Gently pull the weavers to adjust the tension as you weave. All rows should be smooth and close together, and spokes should be at a gently sloped right angle to the base. Maintain the oval shape that was initiated by the guide-string. With 10 rows woven, the weaving will be about ⅝-inch tall and the spoke ends will stick out above the basket about 3 inches (Figure 4c). Do not trim the ends.

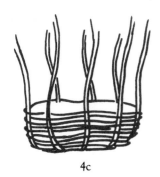

4c

5. To weave the border, be sure that the spokes are quite wet and flexible. Bring each pair of spokes behind the pair of spokes to its right, as shown in Figures 4d and 4e.

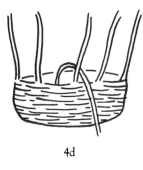

4d

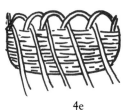

4e

6. Next, bring each pair of spoke ends under the spoke ends to the right and place them, pointing up, next to the curve of the next pair of spokes, as shown in Figures 4f and 4g.

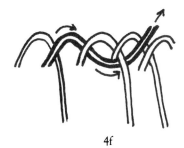

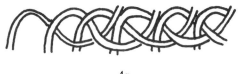

4g

4f

7. To complete the basket, tuck the wet piece of #6 round reed, to be used as the handle, into the inside of the weaving behind the braid. Slide it down to the bottom of the basket alongside a pair of spokes. Then gently bend it over to the opposite side of the basket and slide the other end of the handle into the weaving (Figure 4h).

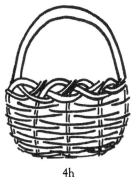

4h

❧ 5 ❧
Miniature Round Basket

SHAPE round with twisted handle

MATERIALS #1 round reed (2 strands), #4 round reed (1 strand), #6 round reed (1 strand)

SIZE 1½ inches in diameter, 2½ inches high

INSTRUCTIONS

1. Cut 4 pieces of #6 round reed, each one 1½ inches long. Cut the reed at an angle to make pointed ends. These will be your base spokes. Cut 8 pieces of #4 round reed, each one 4 inches long. These will be your side spokes. A strand or 2 of #1 round reed will be used for the weavers and for the twisted handles. Do not cut these, but keep all fibers wet until ready to use.

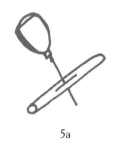

5a

2. Use an awl to carefully make a narrow split in 2 pieces of the #6 round reed (Figure 5a). Do not wiggle the awl back and forth to widen the split; this will split the reed all the way to the ends and make it unusable. Just carefully insert the point of the awl and then, as you draw it out, slide in a piece of #6 to make a cross. Make the base by putting 2 of the unsplit #6 spokes through the centers of the other 2 split #6 spokes (Figure 7b). The split base will help the basket to sit flat.

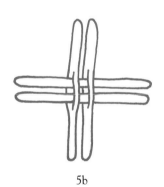

5b

3. This basket is made with the "twining" or "pairing" weave. Take a strand of #1 round reed and bend it in half. Loop the folded reed around 2 spokes, bringing both ends out on top of the next 2 spokes. Then, take the top strand and bring it behind the next 2 spokes and to the outside of the basket again (Figure 5c). Bring the top weaver from this pair of spokes behind the next pair of spokes and to the outside of the basket.

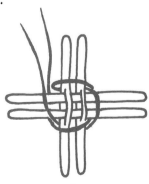

5c

4. As you twine, each weaver changes consecutively from being the top weaver to being the weaver that is behind. This twisting of the two weavers around the pairs of spokes is called "twining." When using the twining stitch, it is important to keep the ends of the weavers on the outside of the basket. This will make it easy to tell which weaver is "behind" and which weaver is on "top." As you weave this pattern, repeat to yourself, "The top one goes behind the next pair and to the outside."

5. On the second round, begin to twine over the spokes one at a time instead of over pairs. Twine the entire base, right out to the ends of the spokes (Figure 5d). Do not cut the ends of the weavers.

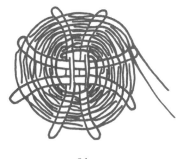

5d

6. Now you are ready to insert the #4 side spokes. If any of the #6 spokes are sticking out, trim them flush to the weaving. Then tuck in a #4 spoke next to each #6 spoke (Figure 5e).

7. Hold the basket with the bottom towards you and the spokes pointing away from you. For this basket, we bend the side spokes at a right angle to the base to produce straight sides. Turn the base so that the spot where you stopped weaving is on top and at the same time, please note on the illustration the direction of the arrow on the base of the basket: this shows the direction of your twining. Keeping the spokes at a right angle to the base, twine to the right, over single spokes (clockwise), as illustrated in Figure 5f.

8. Continue twining until you complete a woven height of almost an inch. This will require 7 rounds of twining, equaling 14 rows of reed. You'll need about 2½ inches of spoke length at the top for the border.

5e

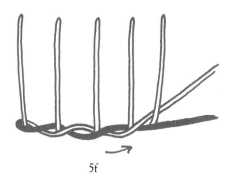

5f

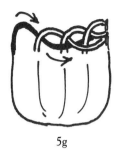

5g

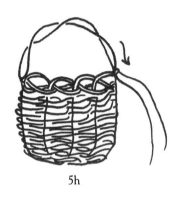

5h

9. To bend down the border, be sure that the spokes are well soaked. Then, take 1 spoke and bend it down behind the spoke to its right, in front of the second spoke to its right, and tuck it into the inside of the basket. Repeat with the remainder of the spokes. Keep the border close to the basket and tight (Figure 5g).

10. To make the twisted handle, cut a piece of #1 round reed 30 inches long. Bring it under the border on one side of the basket, and fold its length in half. Make 3 twists. Holding the last twist, bring the 2 ends of the reed under the braid border, from the inside to the outside of the basket (Figure 5h).

11. Next, bring the 2 ends of the reed back around the handle, twisting the strands into place along the first 3 twists. Trim 1 end so that it is 1 inch long, and tuck it into the weaving under the border (Figure 5i).

12. Bring the other strand back over the basket handle a third time, carrying it along the twists. Trim it also to a length of 1 inch, and tuck it into the weaving under the border. Your twisted handle is finished, and the basket is complete (Figure 5j).

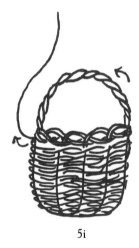

5i

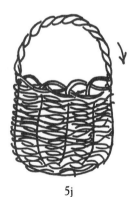

5j

❧6❧
Shaker Cheese Basket

SHAPE round

MATERIALS ½-inch flat reed (about ½ pound), wide binding cane (1 strand)

SIZE 9 inches in diameter, 3 inches high

INSTRUCTIONS

1. Cut 12 pieces of wet ½-inch flat reed, each 16½ inches long. Cut 4 pieces of ½-inch flat reed, each 31 inches long. The 16½-inch pieces are for the body of the basket, and the 31-inch pieces are for the sides and rim of the basket.

2. Arrange 3 spokes as shown in Figure 6a. Place spoke "A" horizontally on the flat surface. Slide spoke "B" diagonally from the left down to the right on top of "A." Add spoke "C" by placing it diagonally from the left up to the right, under "A" and over "C." Check to see that your spokes are placed exactly as shown in Figure 6a, so that you have 6 sections equally spaced around the circle.

3. Building on the center that you began with, add 3 more spokes in each direction. Notice that the "B" spokes are always on top of the horizontal "A" spokes, and that the "C" spokes are always placed under the horizontal "A." Check your layout against the diagram to be sure that all of your spokes are positioned correctly. Notice that there are now 4 crosses in the pattern above the horizontal and 3 crosses below the horizontal. The arrows in Figure 6b illustrate this.

6a

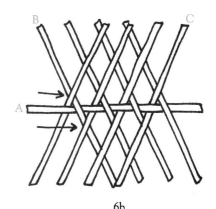

6b

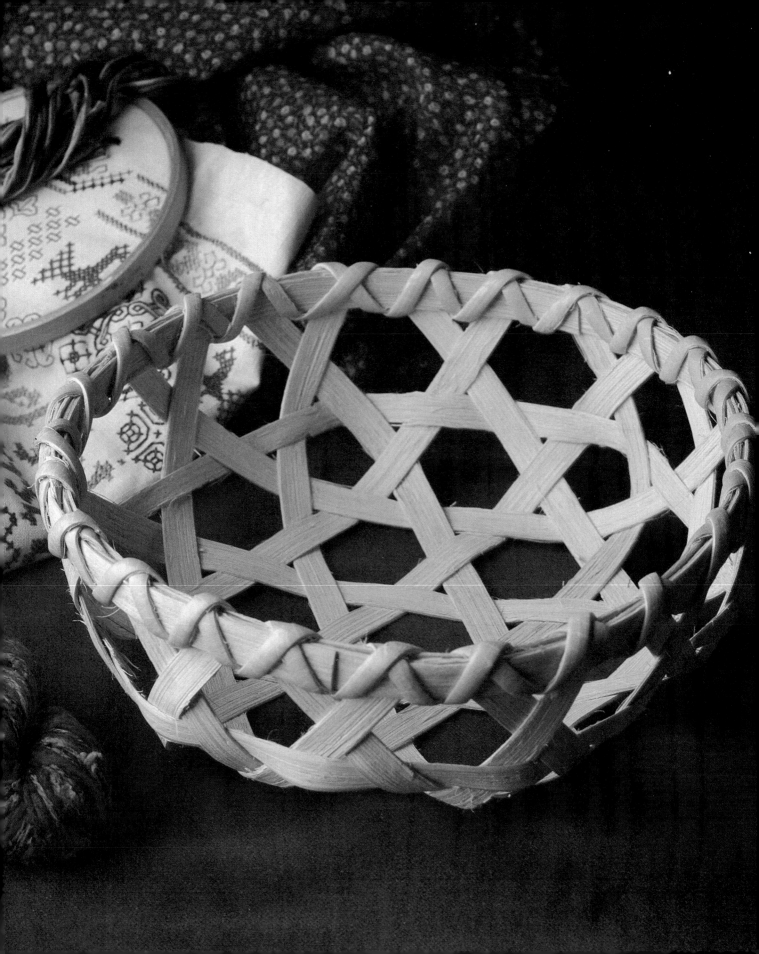

4. Carefully weave another horizontal spoke above the 4 top crosses, as illustrated in Figure 6c. The 3 new crosses (see arrow in diagram) above this new horizontal spoke are arranged with the "C" spokes on top.

5. Carefully weave a third horizontal spoke below the 3 lower crosses and a fourth horizontal spoke above the 3 top crosses, as shown in Figure 6d. The two new crosses at "A," "B," "C," and "D" are arranged with the "C" spokes on top. This completes the hexagonal layout of the base of this basket.

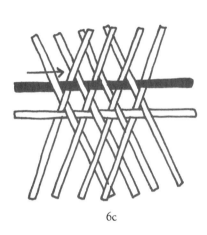

6c

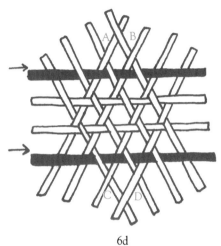

6d

6. To hold the base in place temporarily and make it easier to weave the sides of the basket, weave a circle over and under around the base with a piece of string. As you do so, you will be weaving over and under the new crosses that have formed on the 6 sides of the pattern. Use Figure 6e as a guide. If your woven string does not lay out a circle, you have probably not stayed close to the base on the newest crosses. Compare your circle carefully with Figure 6e and make whatever adjustments are necessary.

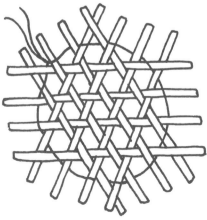

6e

7. With the string tied tightly in place, adjust the position of the spokes so that the hexagonal pattern is centrally located. The spokes should extend about 4 inches from the string all around the base. Notice that 6 crosses are formed on the outside of the circle, and use a clothespin to secure each of these crosses (Figure 6f).

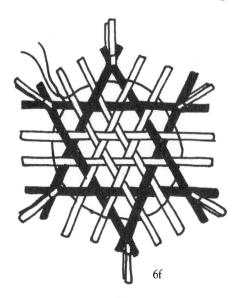

6f

8. Notice that there are 2 straight spokes in between each cross around the base. Deliberately cross each of these remaining spokes and place a clothespin on each. As you look down at the basket, place the spokes with arrows on top of the other spokes when you clip them.

9. Taking 1 of your 31-inch pieces of reed, use it as your first side weaver. Weave it exactly over the base outline string. It will overlap itself about 3–3½ inches as you complete the circle. As illustrated from the side, this reed will be woven under the clothespinned crosses (Figure 6g).

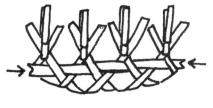

6g

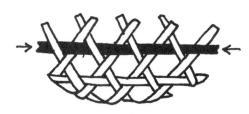

6h

10. Weave the second 31-inch piece of reed in and out of the spokes exactly where the clothespins are. Remove each clothespin as you put the weaver in place. Be sure to insert this weaver so that it locks into place, as illustrated (Figure 6h). It should not slide down inside the crosses. The overlap will be about 3–3½ inches in this circle. Trim the remaining spoke tops so that they are even with the second row of weaving, as shown in Figure 6i. Cut and remove the string from the base.

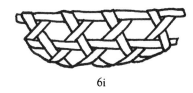

6i

11. The 2 remaining 31-inch pieces are the top bands of the basket. Use clothespins to attach them directly on top of the second row of weaving. Place 1 band inside and 1 band on the outside. See that the overlapping ends of each piece are on opposite sides of the basket, so that you don't accumulate the bulk of too much thickness in 1 spot. The wet strand of wide binding cane will bind the border to the basket. Tuck the end within the band layers, and lash firmly in 1 direction around the border with the shiny side (bark exterior) up. The dotted lines in Figure 6j show the path of the cane on the inside of the basket.

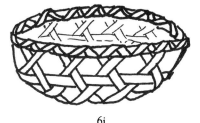

6j

12. After 1 round, reverse direction and complete the zigzag pattern by lashing firmly in the opposite direction (Figure 6k). Run the end of the cane through the inside of the border to secure tightly. Finally, trim the end.

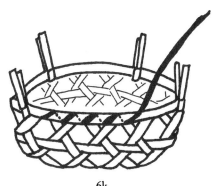

6k

❧ 7 ❧
Pine Needle Basket

SHAPE cylindrical

MATERIALS pine needles (1 shopping bag full), raffia
(½ pound)

SIZE 4½ inches in diameter, 7 inches high

INSTRUCTIONS

1. Gather brown pine needles and air dry them for a day or so. Using the extra long needles (12 inches plus!) of our southern and western North American trees produces the most outstanding baskets. However, even short needles can be used with great success. Do not use green pine needles unless you dry them for at least a week or two. The drying will ensure that the needles have shrunk as much as possible before you stitch them. Baskets made from fresh green needles will look and smell terrific at first, but a few weeks later, these baskets will dry out and your stitches will be loosened.

Once your materials have been gathered and dried, you will be ready to sort 4 to 6 clusters of needles, making a bunch that is about as thick as a pencil. The size of your pine needles, of course, will determine how many you use for each bunch. Thread a needle with a strand of raffia. Lay the end of the raffia across the bunch of pine needles (Figure 7a), and wrap the sheaths completely to fasten the bunches. (The sheaths are the "heads" of the clusters, which hold the individual needles together.)

2. Bend the bunch of pine needles into a tight circle, wrapping as you go and stitching back into the center to hold. The center of the coiling will be completely covered by the raffia. Coil either clockwise or counterclockwise—however is most comfortable for you.

7a

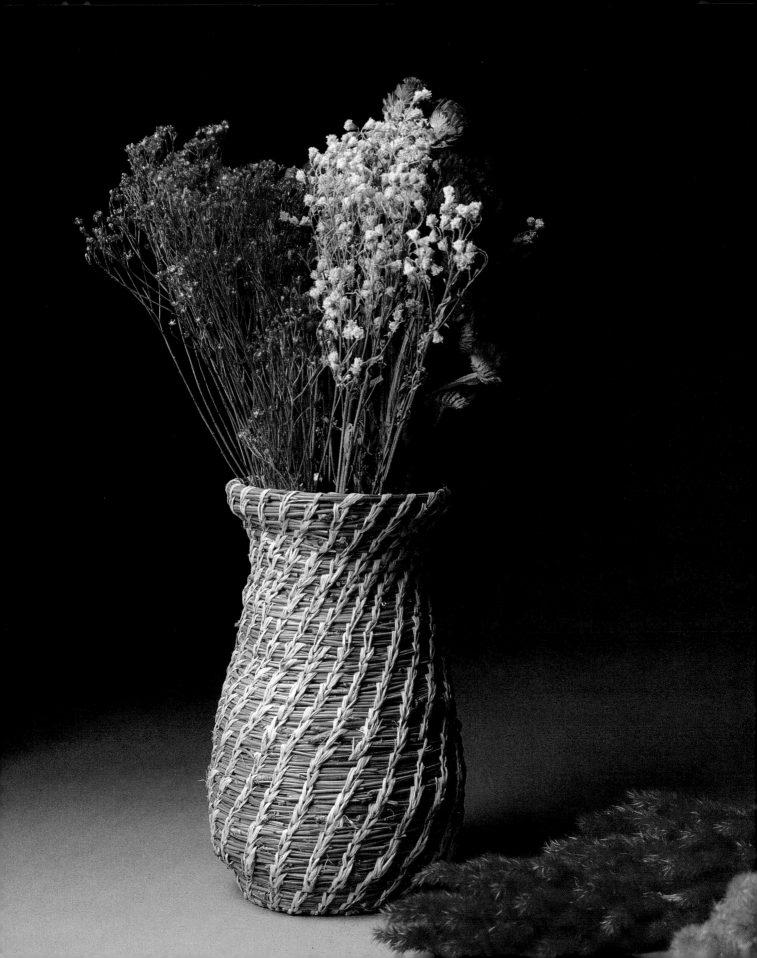

7b

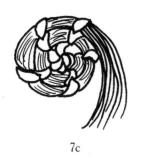

7c

3. Next, to split stitch, pull your needle through the center of the stitch in the previous row as you bring the raffia around the coil (Figure 7b). Be sure that the needle also goes through part of the bunch of needles as it splits the stitch. Repeat on all stitches in consecutive rows. Stitches should be ½ inch to ¾ inch apart (Figure 7c). This procedure produces the split stitch. Although it will look like a chain stitch embroidered on the exterior of the basket, as you have just demonstrated, this stitch is actually the result of coiling.

4. Add a new bunch of pine needles to the coil whenever it starts to get thin. Again, the number of needles added depends upon the size and length of your needles. The raffia will eventually become stringy, but use it until it breaks or becomes unmanageable. To add another piece, tie the new raffia onto the old, close to the basket, and trim the knot ends.

5. After you coil a few rows, you'll find that your stitches are becoming too far apart. On the next row, add a new stitch in between established stitches, as illustrated in Figure 7d. Then continue to split all of the stitches.

6. As already noted, on the right side of the coiling the split stitch will look like an embroidered chain. On the wrong side, it will look like random lashing (Figure 7e). The right side of the coiling will be the underside of the basket. We want the right side to continue up the exterior sides of the basket.

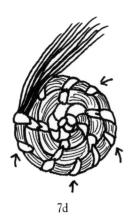

7d

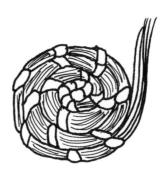

7e

7. Continue to coil until your base measures approximately 3 inches in diameter. Then begin to shape the sides. To coil up the sides, place the row of needles on top of the previous round as you stitch. This first row of the side will form a right angle to the base (Figure 7f). Continue to hold the row of needles in place as you proceed to make each split stitch around the base. The chained design will go up the sides of the basket, and the split stitch of the base will be on the underside of the basket.

7f

8. From here on, coil the basket in whatever shape you wish. Figure 7g suggests 1 possible shape. The shape of the basket is made by gradually adjusting the row of needles either towards a wider or narrower form as you stitch. Keep the rows tight by always stitching through part of the needle bunches as you split the stitch. As you finish your coiling, stitch until you run out of needles. The bunches will get thinner and thinner, blending quite well into the basket edge. Tie a knot and run your raffia into the coiling to hide it. Then remove the needle, and cut the end of the raffia.

7g

Rib Baskets

SHAPE round rib with Eye-of-God patterns

MATERIALS #6 round reed (½ pound), ³⁄₁₆-inch flat reed (½ pound), two 6-inch (10-inch) hoops

SIZE directions are for 2 sizes of rib baskets: 6 inches in diameter, 6 inches high, and 10 inches in diameter, 10 inches high

INSTRUCTIONS

1. As you start to work, please note that the following directions apply primarily to the making of a 6-inch rib basket. Substitute measurements and notes for making a 10-inch rib basket are given in parentheses. Start by cutting 6 (14 pieces) of wet #6 round reed, each one 11 inches (17 inches) long. These will serve as ribs for the basket; each reed will be trimmed to assure a precision fit when the ribs are added to the basket. Cut these reeds at an angle to create a point on each spoke that will facilitate inserting the reeds into the basket. Set aside 2 long strands of ³⁄₁₆-inch flat reed for use in the Eye-of-God patterns on the basket ends. Wind about a dozen strands (3 dozen strands) of ³⁄₁₆-inch flat reed for use as weavers. Keep all fibers in water until you need them, though not longer than 3 or 4 hours. Do not soak your hoops.

2. In preparation for weaving, place the 2 hoops within each other at right angles.

3. Take a long, wet strand of ³⁄₁₆-inch flat reed and lay an end under the cross on 1 side of the basket. Cross over the center and bring the reed around "A" to secure the end (Figure 8a).

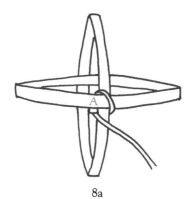

8a

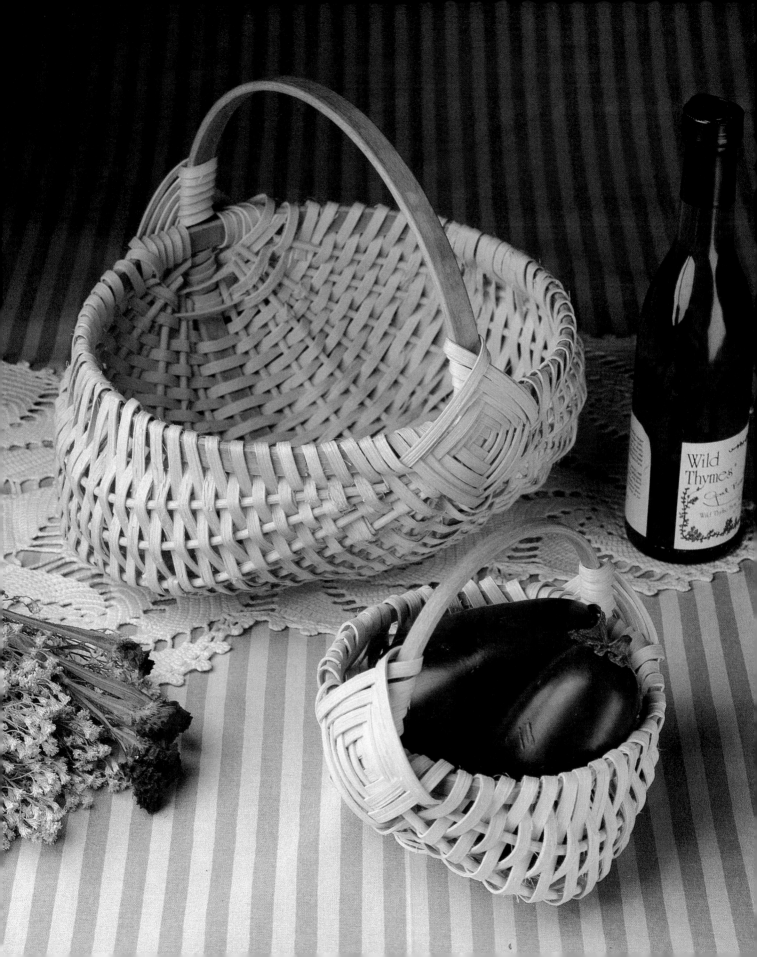

4. Cross and wrap around "B," as shown in Figure 8b.

5. Cross and wrap around "C," as shown in Figure 8c.

6. Cross and wrap around "D," as shown in Figure 8d.

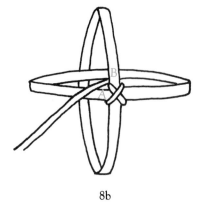

8b

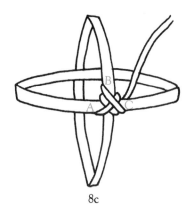

8c

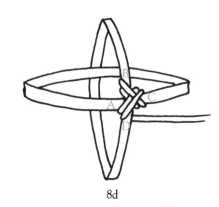

8d

7. Repeat steps 3 through 6 for 5 (6) rounds. As you lay each round of flat reed, slightly overlap the previous round to create a smooth, even pattern. Keep the strands tight. If you lose track of the number of rounds you have made, simply count the loops on the back of the cross to determine how many times you have gone around. After you complete 5 (6) rounds, insert the end of the strand into the last wrap of the pattern and pull to tighten. Figures 8e and 8f show the completed Eye-of-God pattern from the front and back. Do not trim the end of the reed. Use a second long strand of ³⁄₁₆-inch flat reed to repeat the same pattern on the opposite side of the basket.

8. You are now ready to add the ribs that form the skeleton of the basket. First, insert two #6 round reed ribs by placing one on each side of a hoop, running from behind the crosses on one side to the other. The ends will lie in place behind the crosses; they should not tuck into the Eye-of-God pattern. The pressure on their ends will hold them in place until you have begun to weave. These 2 ribs will be used without decreasing the 11-inch (17-inch) length (Figure 8g).

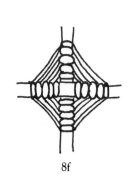

8e

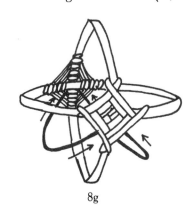

8f

8g

9. Add remaining 4 (10-inch) ribs to basket. For the 6-inch basket, 1 rib will be placed on the left and right of each of the first 2 ribs. These 4 ribs, which will have to be trimmed to fit smoothly, will each be approximately 10 inches long. Before you begin to weave the body of the basket, scrutinize the silhouette of your basket as shaped by the hoops with their 6 ribs. The shape you see at this stage is the shape of the finished basket, so look at it carefully from all sides. If a rib bulges out to make the basket uneven, trim it ½ inch at a time until it looks right. Figure 8h shows the 6-inch basket with all 6 ribs inserted.

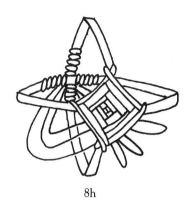

8h

For the 10-inch basket, insert 3 ribs to the left and right of each of the first 2 ribs. As with the smaller basket, the ribs will have to be hand-trimmed to create the desired silhouette. On this larger basket, the ribs will vary in length from 15–17 inches.

10. With the ribs in place, hold the basket upside down with the handle pointing down towards your lap and the ribs of the basket facing up. With 1 of the ³⁄₁₆-inch flat reed strands remaining from the Eye-of-God pattern, use over—under—over—under of plain-weave back and forth around the bottom of the basket. The 3 hoop pieces and 6 ribs will give you 9 ribs to weave on (Figure 8i). Keep the rows close together as you work toward a smooth, rounded shape. You should not be able to see spaces between the rows.

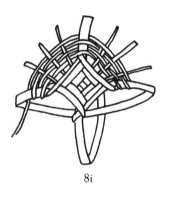

8i

For the 10-inch basket, you'll have 3 hoop pieces plus 14 ribs, a total of 17 ribs to weave on. Weave over 2—under 2 ribs for the first 2 or 3 rows until you can get the spokes spread out evenly and create enough space to weave smoothly over and under each individual rib.

11. When you use up the first weaver, turn the basket around and weave in the same manner on the opposite side of the basket with the rest of the ³⁄₁₆-inch flat reed from the second Eye-of-God. In order to keep the basket symmetrical in shape, weave from the 2 outside edges to the center instead of from one side to the other.

12. To finish the body of the basket, overlap a new weaver as needed and continue weaving towards the center. Be careful to treat the weaver gently, or the reed will fray. Be sure to match the weaving pattern at the center of the basket. Sometimes it's necessary to slide the weaving over and weave in 1 more row so that the pattern will match (Figure 8j).

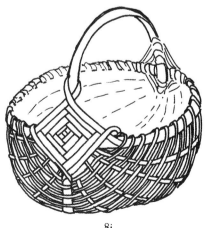

8j

❧ 9 ❧
Market Basket

SHAPE rectangular

MATERIALS ½-inch flat reed (½ pound), ³⁄₁₆-inch flat reed (½ pound), ½-inch flat oval reed (1 strand), ¼-inch flat oval reed (2 strands), one 8-inch wide hardwood handle with notched ends

SIZE 12 inches long, 8 inches wide, 7 inches high including handle

INSTRUCTIONS

1. Cut 10 pieces of wet ½-inch flat reed, each 18 inches long. Cut 13 pieces of wet ½-inch flat reed, each 15 inches long. These will be your spokes. The ½-inch flat oval reed will be used for the outside and inside bands of the top rim of the basket. The ¼-inch flat oval reed will be used for the lashing. (Put both flat oval reeds aside to avoid confusion with your regular flat reeds.) The uncut ³⁄₁₆-inch flat reed will be used as weavers.

2. Lay out the base of the basket, using the 18-inch spokes horizontally and the 15-inch spokes vertically. This is best achieved by making a cross for the center of the base and adding 1 spoke at a time to the top, bottom, and sides of the cross. Reed has a slightly noticeable "right" and "wrong" side. The latter might be rougher, and you should use this rough side for the inside of the basket. So place the reed with the rough side facing upward. Weave the spokes over and under each other to make a plain-weave base measuring 7 inches by 10 inches. Adjust the spoke ends so that they stick out evenly. Secure the base by weaving a piece of twine over and under the entire perimeter of the spokes. Pull up tightly, tie a knot, and trim the ends of the twine. Then, use your scissors to cut any 1 corner spoke as far as the string. This split spoke will produce 2 narrow spokes and give you the odd number of spokes necessary to use plain-weave (Figure 9a).

3. Next, to avoid cracking the spokes as you bend them upright, soak the basket base very well. After soaking, tuck a wet, uncut ³⁄₁₆-inch weaver into the split spoke, as shown in Figure 9b, and use a clip clothespin to hold it in place. As you start weaving, place the bottom of the basket on a flat surface in front of you. Bend up the spokes near the split spoke, and if cracking occurs, soak the base a

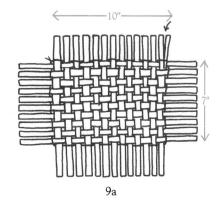

9a

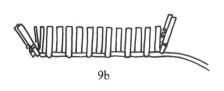

9b

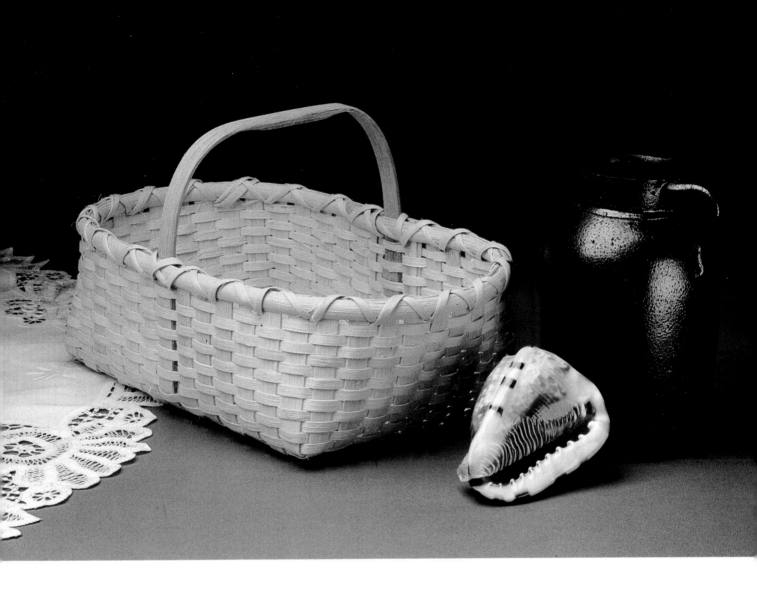

while longer. Weave over and under in plain-weave along the first side. Be sure to have the spokes bent upright as you weave over them. (If you neglect to do so, don't be surprised if your finished product looks like a rectangular plate.) At the next corner, use a second clip clothespin to anchor the row. Clothespins are always very helpful because the first row of weaving is always the most inclined to buckle.

4. Weave the entire first row in plain-weave (over—under—over—under), anchoring the reed with clothespins wherever needed (on corners, or in the middle of a row). Be sure that the spokes are bent upright, and that the weaving is even. Pack down each stitch as you weave it. Never try to weave over and under a few spokes at a time and go back to pack down your stitches later. This almost always results in uneven tension, which, in turn, produces an uneven basket with some stitches too loose and others too tight.

5. Remember to treat the split spoke as 2 spokes now. Keep the end of the first weaver tucked inside the basket. Begin weaving the second row, maintaining the plain-weave by weaving over the "unders" and under the "overs." This second row will lock in the first row. Above all, keep the spokes upright: this will determine the final shape of the basket.

6. The top edge of rectangular-based baskets woven of flat materials will always become oval as you weave the sides. Because this is a natural tendency, you need to do nothing in particular to encourage the rounded shape. (Truly square baskets are generally woven over a mold which maintains a square edge.) After the first two rows, hold the basket in your lap with the spokes pointed away from you and the bottom of the basket towards you. This will ensure that you are weaving on the outside of the basket. You should never weave with your hand on the inside of the basket.

7. Weave 4 complete rounds of plain-weave, ending at the split spoke. Although each successive row becomes easier to weave, it is essential that you pay special attention to the tension. Too loose, and you'll have bulging sides and an uneven shape; too tight, and you'll have a basket that slants inward instead of upward. After completing 4 rows, tuck the handle into the weaving at the seventh (center) spoke, being careful to slide the ends of the handle into the weaving on the inside of the spokes. The bottom ends of the handle should rest at about the first or second row of weaving (Figure 9c). From here on, use plain-weave evenly around the basket, smoothly incorporating the 2 ends of the handle. The weaving will seal the handle smoothly against the spokes, locking it in with the notching. The spacing and tension of the weaving at the handle area should match that of the other spokes. Weave a total of 12 complete rows of plain-weave and end at a split spoke. Do not cut off the tops of the spoke ends.

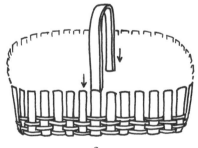

9c

8. Measure a piece of the wet ½-inch flat oval reed for the outside band of the basket. Add 2 extra inches to the measurement of the outside circumference for temporary overlapping of the band. Later, when you lash the band pieces to the basket, the flat oval pieces will be carefully trimmed so that the ends butt tightly against each other. Clip the band onto the basket above the weaving. Place the flat side of the oval reed towards the spokes. The curved surface of the band will be the side that shows, and the band will be on the outside of the handle (Figure 9d).

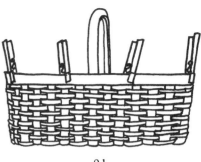

9d

9. Measure a second piece of wet ½-inch flat oval reed for the inside band of the basket. Once again, add 2 inches to the inside circumference measurement, which also will be trimmed off later when you lash the band pieces to the basket. This inside band is shorter than the outside band because the circumference of the rim is smaller on the inside of the basket. Figure 9e shows the bands with the extra overlap. Once again, place the flat side of the oval reed towards the spokes with the oval side towards the inside of the basket. Trim any spoke tops that show above the rim.

10. To attach the bands, tuck a wet piece of the ¼-inch flat oval reed into the weaving near the handle. Then bring it from the inside to the outside of the basket, under the rim, in whichever direction feels comfortable to you. Place the lashing at an angle across the band (Figure 9f), and bring it around to the inside of the basket once more. Put the weaver under the band again—2 spokes over from the first stitch.

Continue to lash on the bands until you get to the other side of the handle. Be sure that the lashing is firm and that the rim pieces are tightened as you lash past them. Don't let the lashing get twisted,

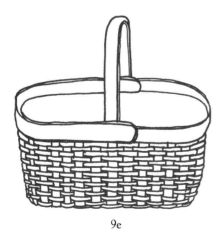

9e

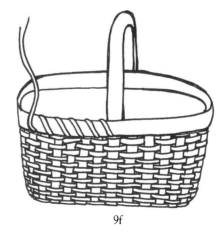

9f

and see that the flat side is placed against the rim bands. As you work past the overlapping cut ends of the bands, carefully trim the ends so that the pieces no longer overlap. Instead, the ends of each band should rest tightly flush with each other.

11. Once you arrive at the other side of the handle, you'll be halfway around the basket. Bring the reed across the front as usual. Then, bring it straight down the back, out to the front at "A," up across at "B," and diagonally down the back to come out at "A" again. (Figures 9g and 9h). This procedure will add both decoration and extra strength to your handle.

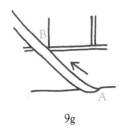

9g

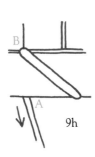

9h

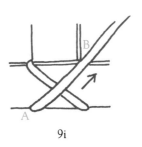

9i

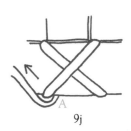

9j

12. Continuing to lash the rim, complete another cross on the opposite side of the basket. After this round, lash in the opposite direction to complete the zigzags shown in Figure 9k. Finish by inserting the end of the lashing strand through the border and weaving several times until it is tight. As you do so, disguise the end of the lashing strand in the pattern weave. Finally, cut the end of the strand from the inside of the basket, and carefully cut and remove the twine from the base of the basket.

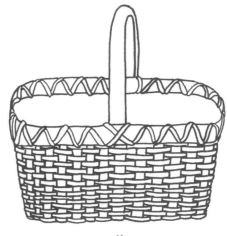

9k

❧ 10 ☙
Heart Basket

SHAPE heart

MATERIALS ½-inch flat reed (½ pound), ¼-inch flat reed (½ pound), medium cane (2 strands)

SIZE 6 inches wide, 3 inches deep

INSTRUCTIONS

1. Cut 8 pieces of the wet ½-inch flat reed, each 11½ inches long. Cut 6 pieces of wet ½-inch flat reed, each 9½ inches long. These are the spokes. Cut 2 pieces of the ½-inch flat reed, each 21 inches long for the top bands of your basket, and put them aside for later use. The ¼-inch flat reed will be used as weavers, and the medium cane will be used to lash the top bands to the basket.

2. The "over—under—over—under" plain-weave will be used to lay out the base of this basket and for the side weaving. To weave the base, use the 11½-inch spokes as illustrated in Figure 10a.

10a

3. Complete the base weaving with the 10-inch spokes as shown by the shading in Figure 10b. With the base completed, compare your base weaving with the illustration to be sure they match. Weave a piece of string over and under the spokes all around the perimeter of the basket to lock in the pattern until the weaving is established. Then split a side spoke by cutting it with a pair of scissors right down to the string (see arrow in Figure 10b). This split spoke will create the odd number of spokes needed to weave in the plain-weave pattern.

4. Insert a ¼-inch flat reed weaver into the split spoke. Weave around the entire perimeter of the basket in plain-weave over—under—over—under. As you weave over each spoke, hold that spoke at a right angle to the base. Spokes must be held upright as you weave them so that they will remain upright permanently. Maintain the tension of your weaving by using clip clothespins on the first few rows.

10b

After 3 or 4 rounds have been woven, the shape of the basket will be established. Keeping a close watch on tension is essential, for if you weave too loosely, the basket will bulge; if you weave too tightly, the basket sides may slant inward. The woven pattern should be smooth and even-textured, with all rows lying close together. This

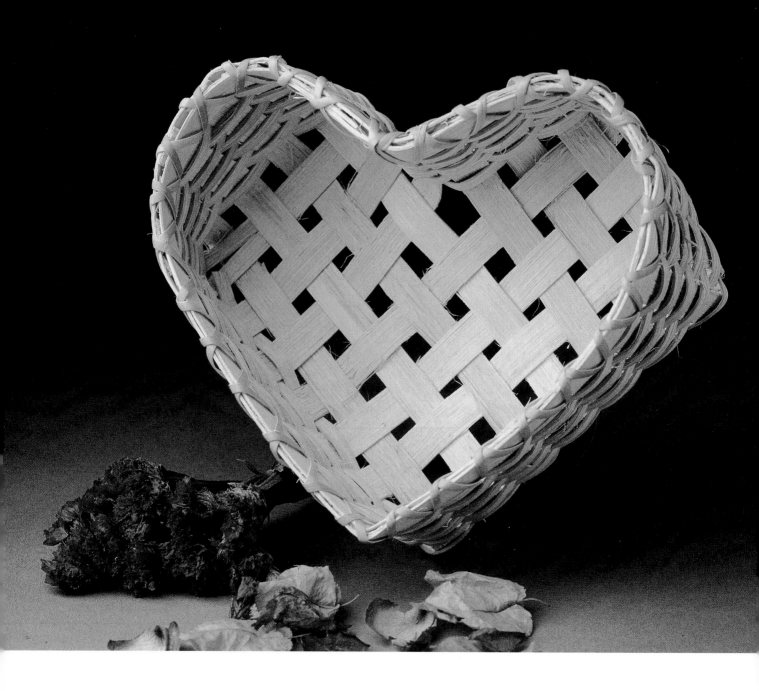

is best achieved by packing down each stitch as you weave it. Never try to weave ahead for a few inches and then go back and pack down the row; this will almost always result in irregular tension.

A heart-shaped basket can be woven from a base with square edges because square-based baskets woven of flat materials become round at the top edge. We can use this characteristic to our advantage when shaping a heart. Emphasize the curved edges while pinching the weavers at "A" and "B" to create the inside and outside points of the heart (see Figure 10c).

5. Weave 10 rows, keeping the sides upright and continuing to encourage the heart shape by creasing the weavers at "A" and "B." Complete the last round by trimming the end of the weaver and tucking it inside the basket. Do not cut off the tops of the spokes.

6. To attach the top bands, position a band on the inside of the basket with clip clothespins. The ends will overlap an inch or 2. Attach a second band on the outside of the basket in the same manner. To avoid the unnecessary bulk that would result from letting all reeds end in the same place, see that the overlapping ends of the outside band do not land in the same spot on the basket as the inside bands. If necessary, trim off any spoke ends that show above the weaving (Figure 10d).

7. Thread the wet medium cane through the basket from the inside to the outside, and use it to lash on the borders. Sew the border pieces on as shown in Figure 10e, pulling up each stitch firmly. Keep the shiny side of the cane facing out, and work in 1 direction all around the basket. The dotted lines in Figure 10e show the path of the cane on the inside of the basket. Occasionally bring the cane under the first row of weaving to anchor the border. Thread it through with your fingers or put the cane on a large needle, but keep it from getting twisted. To avoid breaking the cane, re-soak it if it dries out before you finish work.

8. Remove the clothespins as you sew past them, keeping the cane tight on the border. After you have circled the basket, work back in the opposite direction to complete the zigzags. Fasten the end of the cane by tucking it over and under and securing it inside the basket before you trim off any remainder. Finally, cut and remove the string that was tied around the base spokes when you started to weave (Figure 10f).

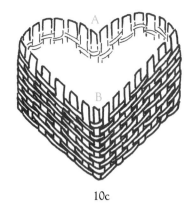

10c

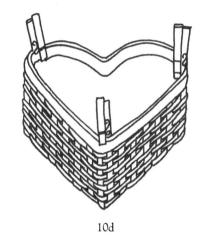

10d

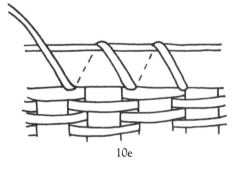

10e

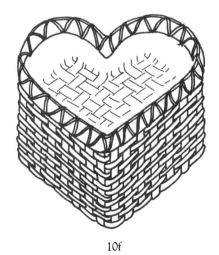

10f

11
Honeysuckle Basket

SHAPE round

MATERIALS honeysuckle vines (2 shopping bags full)

SIZE 10 inches in diameter, 5 inches high

Gathering and Preparing Honeysuckle Vines

Gather honeysuckle vines after the first hard frosts of Fall, when the plant is no longer "in the sap." Pull a single vine from the plant, and cut it free when tugging fails to release any further length. Coil each length of vine into a circle about 7 inches in diameter, picking off any remaining leaves and tucking the end of the vine into the coil a couple of times to prevent unrolling. Never shorten any of the long pieces. You'll soon see that long weavers are preferable to short ones. Where branching tributaries of the vine occur, make a smooth cut close to the main vine to create separate strands. Gather equal amounts of spokes and weavers: the weavers will be about as thick as spaghetti, and spokes will be about twice that diameter. A large shopping bag full of coiled honeysuckle vine should be sufficient for 1 basket.

If you want to make a rustic-looking honeysuckle basket with the bark on, soak the vines in warm water for a few hours or however long it takes to make the vines flexible. If the vines crackle like kindling as you start to weave, put them back into water to absorb more moisture. If they are especially dry and hard, as they would be if gathered after a long drought, they may need a couple of days to absorb enough water to be flexible. This range of soaking times—from hours to days—is due to the varying amounts of moisture in the air (and therefore in the plants) when you gather them.

If you plan to use honeysuckle vine without bark (as shown in our illustration), simmer the vines in a large pot on the stove and check for loosening bark after about a half hour. If you're lucky, the 2 layers of bark will slip off together in one motion. Usually, the brown outer bark slides off easily, but the next layer requires a little help. Use your thumbnail, a jackknife, or a paring knife to loosen an edge of the thin, almost transparent inner layer. Once an edge is pulled away, you can strip off this entire layer to reveal a superb, waxy-textured vine underneath. If you leave patches of the thin inner layer

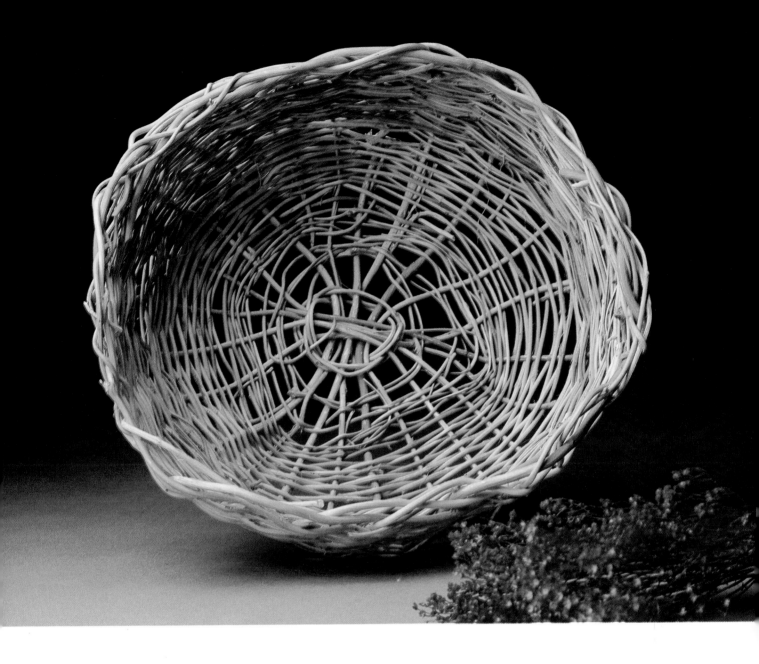

on the vine, they will probably fray off as you weave. But do remove
these scraps as you weave, because the dry, shaggy remnants cannot
easily be pulled from the completed basket. As with the unpeeled
vines, re-soak the peeled vines until they are flexible enough to weave
without breaking. Later, soak the partially finished basket any time
the spokes or weavers start to dry out and break.

When the vines have absorbed sufficient water, they will start to
darken and change color. Check the vines for signs of darkening if
they have been soaking more than 2 days. Darkening, of course,
is not a detraction. The color of the finished product will be deter-

mined by the length of soaking time and is a matter of taste—or chance! After the basket is completed and the vines begin to dry out again, the process will be reversed: the color will become lighter as the basket dries over a period of days, weeks, and months, depending upon the humidity.

Honeysuckle baskets age magnificently. The spokes and weavers seem to get smoother with age; the colors soften, and the fibers strengthen.

INSTRUCTIONS

1. Cut 10 honeysuckle spokes each 36 inches long, using well-soaked lengths of your thicker vines, which may vary in diameter.

2. Place 5 spokes across the 5 remaining spokes at a right angle in the center of their length (see Figure 11a). (Please note that although honeysuckle vine characteristically has many irregular curves, the illustrations for this project will show it as straight. The illustrations also show the lengths of the spokes disproportionately shorter than they actually are.) Temporarily lash the base spokes together with string which will be removed after the basket is completed. Then, take one of your narrowest weavers and weave it under 5—over 5— under 5—over 5 for one round. At this point, bend back the weaver and weave in the reverse direction for a second round, as shown in Figure 11a. Then, insert an extra spoke, as at "A," to create the odd number of spokes necessary for a plain-weave pattern.

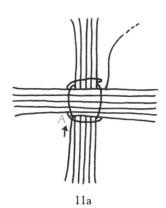

11a

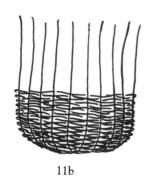

11b

3. From this point on, use the plain-weave of over 1—under 1— over 1—under 1 around the base and for the rest of the basket. When you use up the length of 1 weaver, merely overlap another piece for a few stitches and continue weaving. Watch out for the prickly little nubs left on the vine where you removed branching vines. Otherwise, honeysuckle vine is gloriously smooth to work with.

4. When the basket is 8 inches in diameter, gently coax the spokes upright into a bowl shape as you continue to weave the sides. Weave until the basket is 5 inches high, or until you have approximately 8 or 9 inches of spoke length remaining at the top of the basket. This additional spoke length is necessary for weaving the top border of the basket (Figure 11b).

5. After the weaving has been completed, re-soak the basket thoroughly to assure flexible border spokes. Then, taking any spoke, bend it gently down to its right and weave it behind the next spoke, in front of the second spoke, behind the third spoke, in front of the fourth spoke, and finally, tuck it inside the basket. This also can be described as "under, over, under, over and to the inside." Study Figure 11c before you proceed. Then, repeat this procedure with all other spokes around the perimeter of the basket.

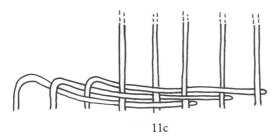

11c

If a spoke should break, replace it with another one. Cut the broken piece flush with the weaving, and slide in a replacement spoke at its side. The natural twists and turns of the honeysuckle vine will produce a wonderfully flowing border, like an ocean wave around the top of your finished basket (Figure 11d). The basket will dry to a waxy texture with the multiple shades of soft colors characteristic of honeysuckle: white, beige, light greens, or light browns.

11d

Honeysuckle Basket

❧ 12 ❧
Grapevine Basket

SHAPE round

MATERIALS grapevines (40 yards)

SIZE 27 inches in diameter, 12 inches high

Gathering and Preparing Grapevines
Gather grapevines at any time of year, cutting only brown vines, which have been through a winter. Green vines, which have not been hardened by frost, will deteriorate. If you harvest your vines in spring or summer, be on guard against any snakes which may inhabit the area.

Grapevines are often found trailing on the ground or climbing trees. Tree-climbing vines are usually easier to harvest. Alternately pull and cut a vine, collecting as much of its length as possible. Cut it free with hand-held pruning shears, but don't trim the overall length of the vine unless you must. Ten to 20-foot lengths are perfect. Later, you'll be shortening some pieces for use as spokes, but you'll want the weavers to be as long as possible.

At home or in the field, trim off the leaves but do not remove the curly tendrils. Keep as much of the bark as possible, removing only the very shaggy sections.

Grapevines generally have several branches near the new growth at the end of the vine. Prune off the extra pieces so that you have lengths of single strands. Grapevine does not need to be soaked; it may be woven in its natural state.

INSTRUCTIONS

1. Using your thickest grapevines, cut 8 spokes, each 6 feet long. Cut 1 spoke 4 feet long.

2. Place 4 of the 6-foot spokes over the remaining 4 spokes of the same length at a right angle to form a cross, as shown in Figure 12a. Note that though the illustrations picture straight pieces of vine for the sake of clarity, your grapevines will probably be curved and irregular-looking. As illustrated in Figure 12a, tightly lash the center of the base with twine which you will cut out of the basket after the basket is finished. Insert the spoke which is 4 feet long into the center

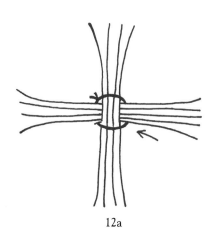

12a

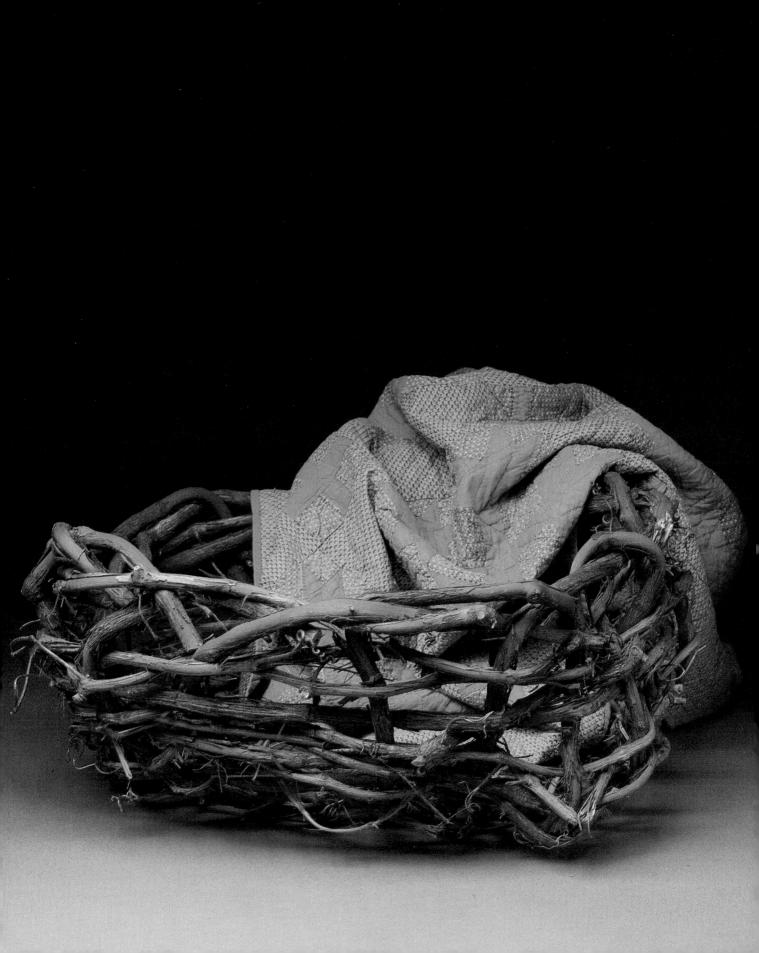

of the base so that its end is caught by the twine. This extra spoke is necessary to create the odd number of spokes required for plain-weave.

3. Spread out the spokes. Place your thinnest piece of grapevine near the center and weave over—under—over—under in plain-weave for 1 round (Figure 12b). As you weave the first 2 rows, feel how much flexing the grapevine can handle without breaking. Try to manipulate the vine carefully around the spokes, adjusting it as needed to follow its natural twist. The grapevine spokes and weavers will undoubtedly be twisted and irregular so be open-minded about your expectations, and know that the woven rows will not be picture-perfect, as they would be if factory-processed reeds were used. If this is your first attempt at basket-weaving, the emphasis will be on texture and fiber, not pattern and form.

As you begin to weave, be careful as you draw your hand down the length of the weaver. Tendrils, knots, and trimmed branches can be very rough.

4. On the second round, weave over the "unders" and under the "overs" to complete the plain-weave pattern. Place the second row as close to the first row as possible. The size and flexibility of the grapevine will be the determining factor. Even 1 inch between the first couple of rows is quite acceptable. Because the spokes will tend to move back and forth and disrupt your pattern, you may find when you begin the second round that at certain places the pattern is over—over or under—under. Although you may think that you've made a mistake, it is more likely that the spokes have shifted out of place and thrown the pattern off. Just pull them back into place as you work.

5. Continue to weave the basket base in plain-weave until the diameter reaches 10 inches. If a weaver breaks frequently, discard it and try another piece. Once the base is 10 inches in diameter, begin to shape the basket upwards into a bowl shape.

6. Weave the sides of the basket, pulling in the shape by keeping the spokes close together—about 4 or 5 inches apart. When you have used up a weaver, tuck it into the weaving (Figure 12d). Begin a new weaver by tucking the end into the weaving at the previous spoke. There will be a slight overlap of beginning and ending weavers.

12b

12c

12d

7. Weave until you have used up all but 16–18 inches of spoke length. This remaining length will be used for the border. The bowl of your basket will be about 27 inches in diameter, though this figure is extremely variable. Depending upon how much you pulled in the shape of the basket while weaving, it could be as much as 6 inches larger or smaller.

8. To weave the border, first check the flexibility of your spokes as determined by their thickness and density. If your spokes are absolutely rigid, you may have to tuck them into the spoke spaces by bringing the spoke end into the second spoke space to its right. Repeat this procedure around the basket (Figures 12e and 12f).

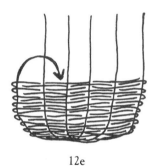

12e

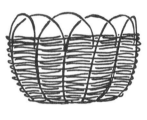

12f

9. If your spokes are reasonably flexible, you may try bringing a spoke down to its right, close to the weaving, bending it over the next spoke, and tucking it to the inside of the basket. The end spoke will rest behind the next spoke, as shown in Figures 12g and 12h. Repeat this procedure all around the basket.

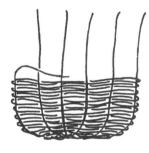

12g

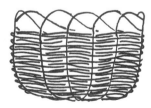

12h

❧13☙
Double-Wall Fruit Basket

SHAPE round, with pedestal base

MATERIALS #4 round reed (1 pound), #2 round reed (several strands), #3 round reed (½ pound), #3 smoked round reed (½ pound), several strands of #3 round reed dyed peach color

SIZE 16 inches in diameter, 7 inches high

INSTRUCTIONS

1. This double-wall basket is woven in 2 layers. First, the bottom and inside layer are woven in the usual manner. Then, the spokes, which are doubly long to accommodate the double layer, are turned down at the top, and the outside layer of the basket is woven from the rim downward.

Cut 16 spokes of wet #4 round reed, each 60 inches long, and 2 spokes of #4 round reed, each 30 inches long. These will be the foundation spokes of the basket. Cut 34 additional spokes of #4 round reed, each 28 inches long. These will be the secondary spokes. The brown exterior of the basket is composed of the #3 smoked round reed. Using basket dye or household fabric dye, dye the natural #3 round reed with an accent color of your choice.

2. Organize the 60-inch spokes into groups of 4. Place 4 spokes over 4 spokes to form a cross; then place a second group of 4 over 4 cross on top of the first, as shown in Figure 13a. Insert a 30-inch spoke to the left and right of 1 set, as shown, tucking the ends into the center. Use a piece of raffia or string to temporarily secure groups of 4 in the base pattern until the weaving is established (see Figure 13a). This string will be removed once you have finished weaving.

3. Tuck a strand of #2 reed into the base, and use it to weave over 4 spokes and under 4 spokes around the base for 2 rounds. **Exception: Where you inserted the two 30-inch spokes, weave over or under 6 spokes. Then, reverse direction and weave over 4 and under 4 for 2 additional rounds (Figure 13b).

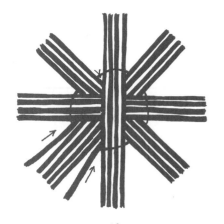

13a

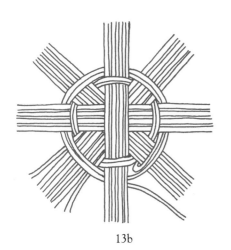

13b

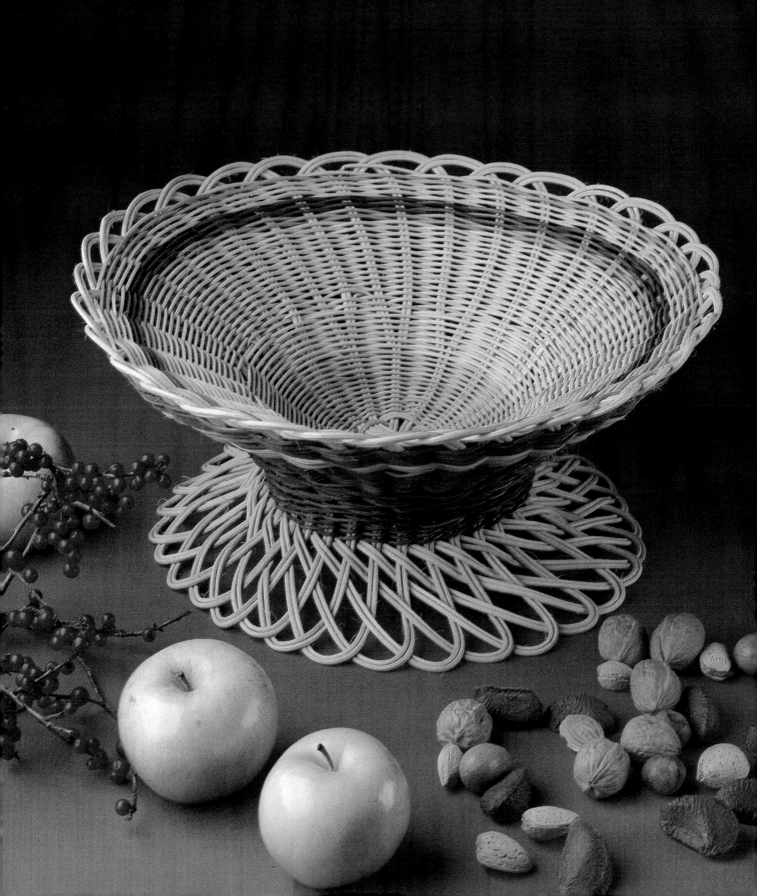

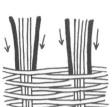
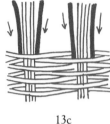

13c

13d

4. Next, weave over 2 and under 2 in plain-weave until the basket reaches a diameter of 8 inches. While you are weaving, flex the spokes to establish a shallow bowl shape no deeper than 2 inches when the basket reaches 8 inches in diameter. Measure width versus the depth frequently so that you don't discover too late that you've created a deep, narrow container.

5. When inserting the secondary spokes, in order to maintain the desired spoke-weaver ratio, you will have to almost double the spokes when the basket reaches 8 inches in diameter. Insert your 34 secondary spokes (28 inches long) by adding 1 spoke on each side of each pair of spokes except the last pair (Figure 13c). You will now have 33 pairs of spokes.

6. Weave over these 33 pairs of spokes (over 2—under 2) until the basket reaches a diameter of 12 inches and a height of about 3 inches. Add a colored weaver here for 3 rounds, and then a smoked reed weaver for 5 rounds. Finish up with 6 rounds of natural reed, 2 rounds of colored reed, and 2 rounds of natural reed. At the same time, continue to monitor the shape of the bowl. The basket should now measure 14 inches in diameter and approximately 4 inches in height. This completes the inside layer of the basket.

7. Before proceeding to the next step, soak the basket to be sure that the spokes are flexible. Then, working on the outside of the basket, bring any pair of spokes behind the pair of spokes to its right and then to the outside of the basket (Figure 13d). Repeat the same procedure around the perimeter of the basket. The idea is to run these spokes back down the outside of the basket, parallel with the inside spokes.

8. To weave the exterior of the basket, hold the basket in your lap with the bottom of the bowl facing upward. The spokes, which you have just turned down at the outside of the base, will point away from you. Loop a strand of #3 smoked reed over any pair of spokes and weave in the twining-weave design from left to right. The twining-weave requires that you bring the top weaver behind the next pair of spokes and to the outside of the basket again. Then take the top weaver from this pair of spokes, and bring it behind the next pair of spokes and to the outside of the basket. As you twine, each weaver goes consecutively from being the top weaver to being the weaver that is behind. This twisting of 2 weavers around the pairs of spokes is called "twining." It is very important, when twining, to keep the ends of the weavers on the outside of the basket. By so doing, it

always will be easy to tell which weaver is "on top" and which weaver is "behind." As you weave this pattern, repeat to yourself:"The top one goes behind the next pair and to the outside" (Figure 13e).

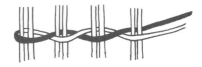

13e

9. Twine the entire outside of the basket, keeping the weaving close to the inside layer of the basket. (There should be only a slight hollow space between the 2 layers.) Close weaving is accomplished by pulling your weavers firmly as you twine. The wet weavers may even squeak as you pull them tightly into position. At the same time, be sure that the spokes are upright, not slanting, across the basket. Use smoked reed for most of the basket, adding accents of natural and colored reed as desired. Weave 1 inch beyond the original base.

10. Before weaving the pedestal base, soak the spokes well. With the spoke ends pointing away from you, the open bowl of the basket facing your lap, bend any pair of spokes sharply down to its right at a 45-degree angle. As you bend, bring this pair of spokes behind the next pair to its right, on top of the second pair, behind the third pair, on top of the fourth; then finish by tucking the spoke ends behind the fifth pair of spokes and into the hollow space between the 2 layers of weaving (Figure 13f). Compare your first pair of bent spokes with those pictured in Figure 13f, and keep the pattern well in mind as you proceed.

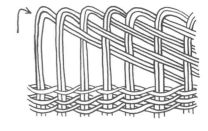

13f

Continue to bend and weave the remainder of the spoke pairs from left to right around the basket. The spokes should be interwoven in a parallel manner and the spacing kept even. When you have finished (see Figure 13g), turn the basket upright and flex it gently to spread the pedestal base. Make whatever minor adjustments to the spacing are necessary to provide a smooth, even pattern. The spoke ends will rest inside the space between the 2 layers. If the basket seems "bouncy" or top-heavy on its base, this can easily be corrected by weighing the basket down with a bag of sugar until it is dry.

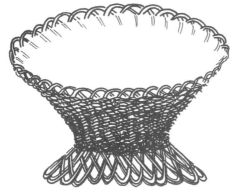

13g

❧14❧
Bushel Basket

SHAPE round

MATERIALS #5 datu, #8 datu (1 pound each)

SIZE 17 inches in diameter

INSTRUCTIONS

1. Cut 16 pieces of well-soaked #8 datu, each one 51 inches long. Cut 1 piece of #8 datu, 26 inches long. These are the spokes of the basket. The #5 datu will be used full length for the weavers.

2. Lay out a base by interweaving 4 sets of 4 (51-inch) spokes as shown in Figure 14a. Use a piece of string or raffia to temporarily fasten the base pattern over and under in groups of 4. (Cut the string out of the basket when you have finished weaving.)

3. Using a strand of wet #5 datu, weave over and under groups of 4 spokes for 2 rounds. Then, reverse direction, and weave over and under the spokes for 2 additional rounds. Insert the 26-inch spoke next to any set of 4 (Figure 14b).

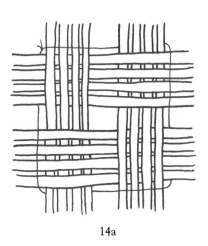

14a

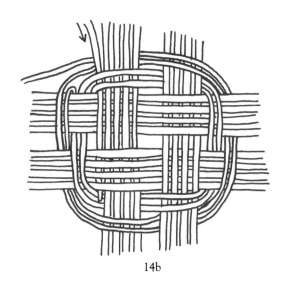

14b

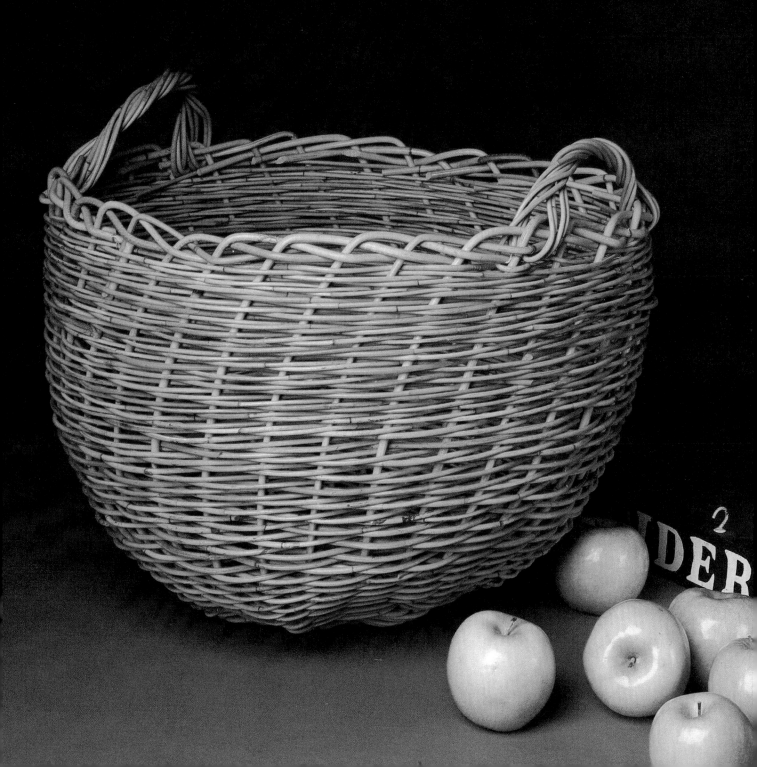

4. Continue weaving the base over 2 and under 2 spokes. After each round, the pattern will "stagger," resulting in what is known as a "twill-weave" (Figure 14c).

14c

5. When the base measures 10 inches, stop weaving and place the basket skeleton into a large stock pot or round bucket. Press the base firmly into the pot so that the spokes are as upright as possible. Then, using the pot as a mold to establish the upward shape of spokes, let the basket dry out completely overnight. If you do not have a container that is large enough, you may tie several rounds of string or reed around the top of the basket. You will probably need someone to hold the spokes up in the desired shape while you tie the string in place.

6. The next day, remove the basket from the pot (or cut away the string) and continue working in twill-weave: over 2 and under 2, keeping the rows smooth and close together. The result should appear as smooth ripples on the surface of the basket. As you weave, pull in the spokes and draw the weaver as firmly as necessary to maintain the shape of the basket. To add new weavers, just lay the first end inside the basket, resting it against a spoke and overlapping the new weaver. Then continue weaving. Unless your weaving environment is extremely dry, you may not have to soak the datu weavers. They are extremely flexible even when dry, and at this stage of weaving, they will not be bent into acute angles. If they break frequently, soaking is in order. Weave until 6 inches of spoke ends remain.

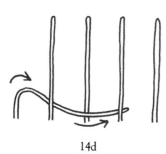

14d

7. To weave the border, bring any spoke end down to its right, behind the next spoke, and in front of the second spoke; tuck the end to the inside of the basket behind the third spoke (Figure 14d). Repeat the same procedure with the remaining spokes around the basket circumference.

8. Decide where you want the handles of the basket. For the best possible design, place handles parallel to the 4 × 4's in the base pattern. Then, insert a long strand of the #5 datu under the border of the basket, pull it up, and bend it approximately in half. Make 3 twists in the double strand of datu (Figure 14e), and hold the third twist firmly with 2 fingers while you thread the ends from the inside to the outside of the basket. Thread these ends under the basket border about 4 spokes over, or at whatever distance you need to produce the handle size and shape you desire.

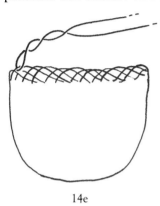

14e

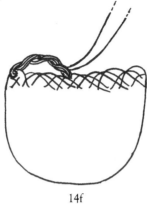

14f

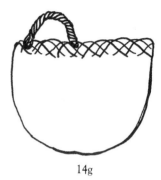

14g

Still holding the third twist so it will not unravel, wrap the handle with the datu, allowing it to twist into the path of the first 3 twists. (If the datu crosses the twists, you are threading from the wrong side of the twist: just pull it out and start again from the other side.) On the opposite side of the handle, dip under the border again and repeat twisting in the path of the initial twists (Figure 14f). When the weight of the handle suits you (Figure 14g), finish off by interweaving the datu ends to mesh with the twill-weave under the border. For a balanced appearance, finish one strand on each side of the handle. Repeat this same procedure to make a handle on the opposite side of the basket (Figure 14h).

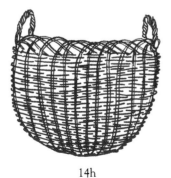

14h

❧ 15 ❧
Swing-Handled Basket

SHAPE round

MATERIALS ¾-inch flat reed (½ pound), ¼-inch flat reed (½ pound), ½-inch flat oval reed (1 strand), ⅝-inch half-round reed (1 strand), wide binding cane (1 strand), 7½-inch spread swing handle

SIZE 8 inches in diameter, 5½ inches high (12″ high including handle)

INSTRUCTIONS

1. Cut 8 pieces of wet ¾-inch flat reed, each one 20 inches long. These will be your spokes. Notice that the reed has a slightly noticeable "right" side, which is very smooth, and a "wrong" side, which is slightly rougher.

To determine right and wrong sides, flex a spoke into the letter "V." If it splinters on the outside of the "V," you have the reed wrong side out. If the reed stays smooth and few fibers pop up, the reed is positioned with the right side out. On the whole, these right and wrong sides make no difference in the weaving of the basket. However, the spokes are going to be turned down at the top to fasten the inner rim. Therefore, for the smoothest possible appearance, keep the rough side of the spokes on the inside of the basket and the smooth side on the outside of the basket.

2. With the rough side facing up so that it will be inside of the basket, lay out your base pattern. Place a cross of 2 spokes upon another cross of 2 spokes; then add a third and fourth cross of spokes, as illustrated in Figure 15a, for a total of 8 spokes. Weave a piece of string or raffia over and under these spokes to secure the base temporarily, and remove this string after you finish weaving. Adjust the length of the spokes evenly around the center of the base.

3. Insert a weaver of wet ¼-inch flat reed, and weave the first round in the same path as the string (see Figure 15b). Then, add a second ¼-inch flat reed weaver, and weave the second round with this new piece. This weaving variation was frequently used in antique baskets to create a mock plain-weave over an even number of spokes—in this case, over 16 spoke ends. Two weavers are used instead of splitting

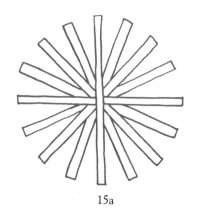

15a

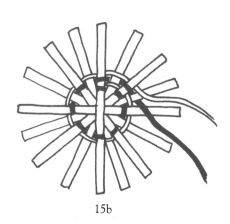

15b

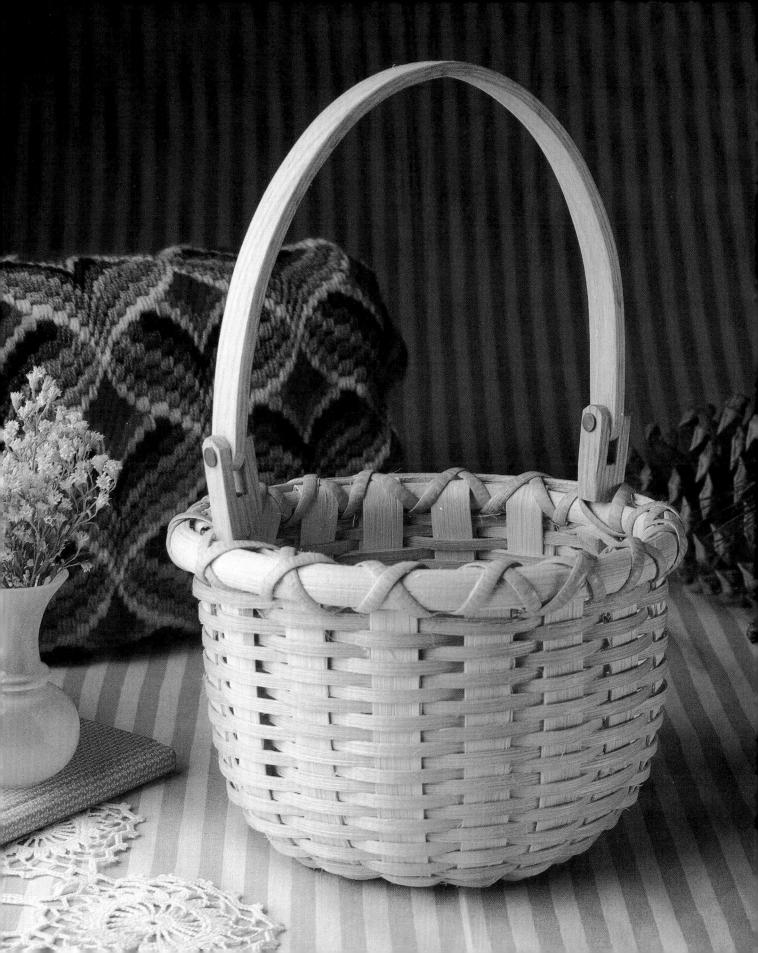

a spoke to create the odd number of spokes normally necessary for plain-weave. In this method, one weaver weaves all of the "overs" and the other weaver weaves all of the "unders."

4. Continue weaving the basket base with the 2 alternating weavers. You have 2 choices for manipulating the reed: use whichever method feels more comfortable. Either weave 1 round with the first weaver, and then weave with the second weaver to catch up to the first weaver's place; or, weave with the 2 weavers simultaneously to create the mock plain-weave pattern of over—under—over—under.

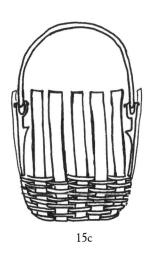

15c

5. When a diameter of 5 inches is reached, begin to shape the sides of the basket by holding the spokes at a right angle to the base and pulling the weavers more firmly to tighten the spokes into an upright position. Take care not to pull too tightly or your basket will slant inward. If you spot bubbles or loose spots in the weaving, stop and adjust the weaver—either tighter or looser, as necessary—before proceeding. When the sides of the basket are about 2 inches tall, insert the handle by sliding it into the weaving on the inside of the spokes (Figure 15c).

Continue to weave, smoothly and firmly securing the handle into place until you have woven to the top of the notched area of the handle. The sides of the basket will be about 5½ inches high. Your last 2 rounds of weaving should rest inside the notched area of the handle. Do not trim the spoke ends. Re-soak the basket to ensure maximum flexibility when turning down the spoke ends.

6. To begin turning down the spoke ends, take any spoke end, turn it down, and weave it back into its own path in the weaving on the inside of the basket (Figure 15d). Camouflage the spoke end by securing it behind a weaver; if necessary, trim the end to size. Repeat the same procedure all around the basket.

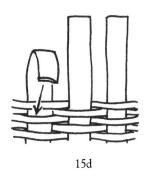

15d

7. To attach the bands, use clothespins or carpenter's clips to hold a piece of ½-inch flat oval reed on top of the last 2 rows of weaving. Place the reed on the inside of the basket and rest it within the notched area of the handle. This will be the inside rim. Be sure that the flat side of the reed rests directly against the spokes. Measure and trim this inner band so that there is an overlap of about an inch.

8. Next, bend a well-soaked length of the half-round reed and clip it to the top outside rim of the basket, using either clip clothespins or carpenter's clips. Don't trim the length yet. Instead, let the band dry overnight. It will dry and shrink into shape on the outer rim of the basket and will be much easier to work with on the next day. Figure 15e illustrates the position of the bands.

9. On the following day (or later), carefully cut the outer band of half-round reed. Using your pruning shears, make a long diagonal cut on one end of the reed and a matching diagonal cut on the opposite end, so that the 2 pieces mesh together smoothly as illustrated in Figure 15f. As you trim, cut at the same angle as you will use for the cane lashing that will secure and conceal the ends of the half-round band.

10. Now place the lashing on the outer rim. Take a well-soaked length of wide binding cane and slide it under the rim and above the last row of weaving. The smooth (bark) side should be on the outside. Bring the cane diagonally to either the right or left, carrying it around the outside and inside borders of the basket. Bring it once again under the rim, above the last row of weaving and to the outside of the basket (Figure 15g). The dotted line shows the path of the cane on the inside of the rim.

Continue to lash around the basket border. If you wish, lash a decorative "X" at the handles. When you reach the diagonally-cut edges of the half-round band, deliberately angle the cane to conceal the cut edges. When you return to the place where you began lashing, reverse, and lash in the opposite direction, completing the zigzag pattern of the cane. Slide the cane firmly into the core of the bands, pull tightly, and trim the end (Figure 15h).

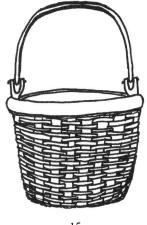

15e

15f

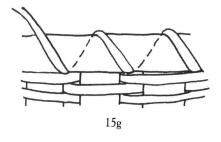

15g

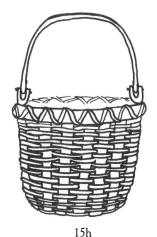

15h

16
Wall Pocket Basket

SHAPE rectangular with pouches

MATERIALS ⅝-inch flat reed (½ pound), ¼-inch flat reed (½ pound), medium cane (3 strands)

SIZE 8 inches long, 12 inches wide, low pocket 4 inches deep, upper pocket 2½ inches deep

INSTRUCTIONS

1. Cut 11 pieces of wet ⅝-inch flat reed 22 inches long and 4 pieces of ⅝-inch flat reed 16 inches long. These will be the spokes for the main body of the basket. Cut 9 pieces of wet ⅝-inch flat reed 7 inches long and 3 pieces of ⅝-inch flat reed 11 inches long. These will be the spokes for the small basket that is attached to the top of the frame. Additional ⅝-inch flat reed will be measured in place for the inside and outside bands of the basket pockets. The ¼-inch flat reed will be used as weavers throughout, and the medium cane will be used to lash on the borders.

2. Begin by laying out the base of the main basket with the bottom pouch. Use the 22-inch spokes vertically and the 16-inch spokes horizontally to form a base layout, as illustrated in Figure 16a. To achieve the appropriate spacing, make sure that the small, square holes between the spokes measure ¼ inch. The base weaving will measure 3 inches × 8½ inches (see Figure 16a). The spokes will extend 15 inches above the base weaving, 4 inches below, and 4 inches on each side of the base. With a piece of string or raffia, to be removed later, weave over and under the spokes to secure the base during the weaving. Split one 4-inch corner spoke with a pair of scissors to create the odd number of spokes necessary for the plain-weave pattern.

Notice that the reed has a slightly noticeable "right" and "wrong" side. The right side is slightly smoother and should be used as the outside surface of the basket. The inside is slightly rougher and should be used as the inside surface of the basket. To tell which is which, flex a spoke into a "V" shape. The side that splinters at the bend is the rough inside surface.

3. Bending the spokes at a right angle to the base (the 15-inch ends will become the wall hanging part of the basket), insert a length of

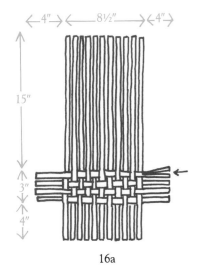

16a

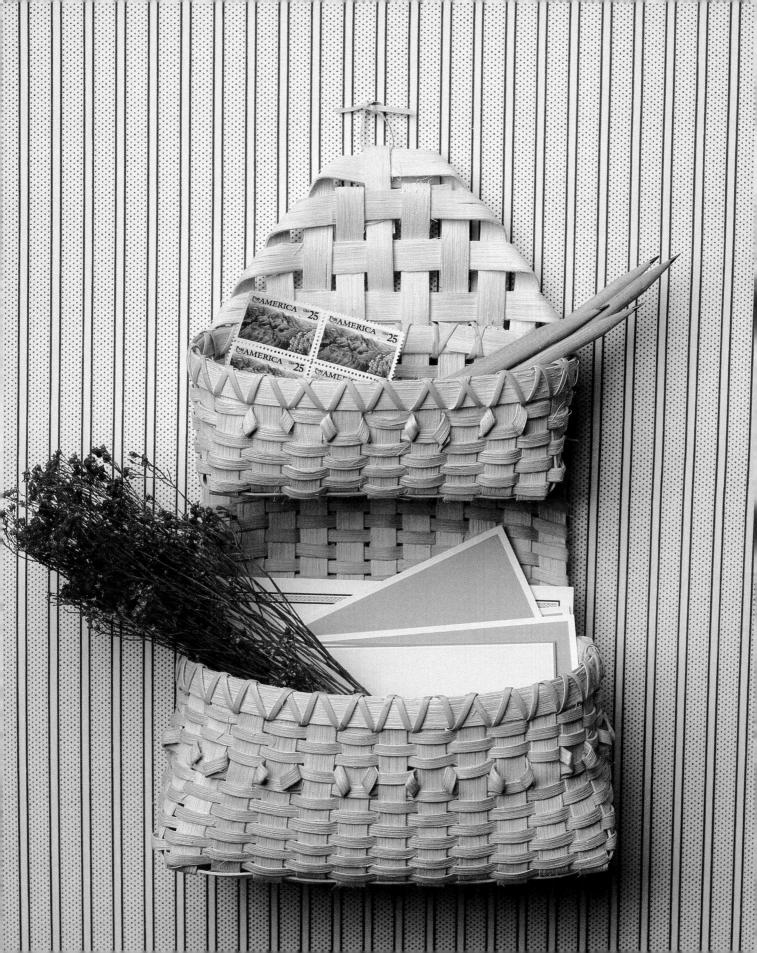

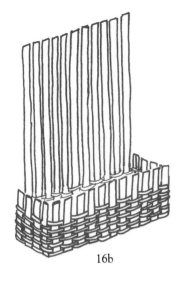

16b

¼-inch flat reed, and weave your first row directly in the path of the string or raffia. Because keeping the spokes at a right angle to the base determines the shape of the basket, be sure to do so from the very beginning. Weave for 9 rounds, maintaining a smooth tension and adding weavers as necessary. Stop weaving at the split spoke, but do not cut the weaver (Figure 16b).

4. Use a new strand of ¼-inch flat reed and start weaving after the split spoke. Run the strand in the same path as the last weaver and directly on top of that weaver for 1 stitch. Then curl the strand of reed (see Figure 16c), and bring it behind the second spoke. Bring it to the front of the spoke, curl it again to complement the first curl, and bring the reed behind the third spoke. Repeat this pattern around the basket for 1 course. (The shaded weaver in Figure 16c illustrates the path of the previous flat weaver.) Then trim and tuck the end of the curly weaver to the inside of the basket. Continue your plain-weave pattern for 4 more rounds, ending at the split spoke. Do not trim the spoke ends, and do not cut the weaver.

16c

5. Use clip clothespins to attach a band of ⅝-inch flat reed both inside and outside the basket, directly above the last row of weaving. First, clip the end of the reed at the center inside, bring it to the left inside the basket, carrying it smoothly around the left rear corner and around the front of the basket. At the right rear corner of the basket, curve smoothly around to the inside of the basket again, bringing the reed back to where you started. Overlap the ends about 2 inches, trim excess, and clip in place (Figure 16d). The band will not cover the rear spokes, which now extend about 12 inches above the weaving. Do not cut these rear spokes, but trim the spoke ends that stick out above the rim of the front and sides of the basket.

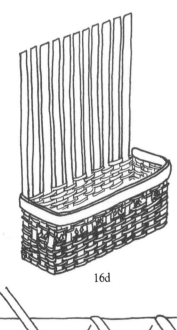

16d

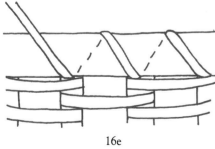

16e

6. Use medium cane to lash on the bands, first working diagonally in 1 direction around the entire top of the basket. The dotted lines in Figure 16e illustrate the path of the cane on the inside of the band. Finish lashing by reversing direction and completing the zigzag pattern of the cane. Tuck the cane end firmly through the weaving and trim the end.

7. With your ¼-inch flat reed weaver, continue weaving over the 11 spokes that make up the rear wall of the basket. Weave smoothly back and forth with the ¼-inch flat reed until the basket is 9½ inches high.

8. To interweave the top spoke-ends, bend the left outside spoke and the right outside spoke towards the center of the basket, and interweave their ends into the plain-weave, as shown in Figure 16f. Repeat with the remainder of the spokes, except the last 3. Bend the last 3 spokes to the rear of the basket and weave the ends into the pattern, as illustrated by the arrows in Figure 16f. Use a piece of medium cane to make a hanging loop.

9. To make the top pocket, lay out the nine 7-inch spokes and the three 11-inch spokes in the base pattern shown in Figure 16g. Temporarily lash the base with string or raffia, and split a corner spoke. Insert a ¼-inch flat reed weaver and, holding the spokes at a right angle to the base, weave 6 rounds in plain-weave, ending at the split spoke. Keep the tension firm and smooth. Without cutting the weaver, insert a second weaver and weave a decorative row of "curly" (see Step #4) around the front of the basket. Cut the curly weaver and tuck the end into the weaving. Pick up the original weaver and continue weaving behind the curly for 1 round to finish the basket.

10. Use clip clothespins to attach a band of ⅝-inch flat reed on the inside and a separate band on the outside of the basket. Overlap the ends of each piece for about 2 inches and trim the excess length. Also trim any excess spoke length which may extend above the rim. Use medium cane to lash the bands onto the basket in a diagonal pattern, following the same procedure used for the main basket (Figure 16h).

11. Finish by using medium cane to lash the pocket onto the top of the wall-hanging section, positioning the small basket as shown in Figure 16h.

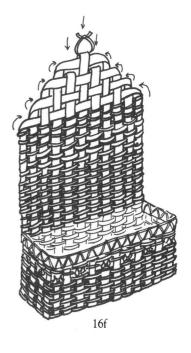

16f

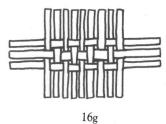

16g

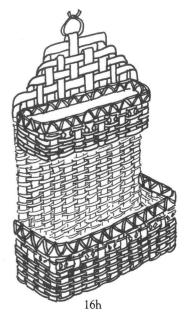

16h

Wall Pocket Basket **127**

❧ 17 ☙
Woven Mat

SHAPE round

MATERIALS #2 round reed (½ pound), #1 round reed (2 strands)

SIZE 12 inches in diameter

INSTRUCTIONS

1. Cut 24 spokes of wet #2 round reed, making each 18 inches long. The #1 and the rest of the #2 will be used as weavers.

2. Lay out a base with 6 groups of 4 spokes as shown in Figure 17a. Note that the illustration does not show the full length of the spokes.

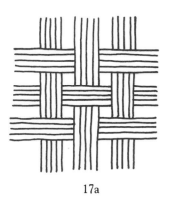

17a

3. Fold a long length of #1 round reed almost in half, the ends about 6 inches apart so that you do not use up each side at the same time. Loop the strand of reed over any group of 4 spokes and use the twining-weave for 2 rounds over the groups of 4. Figure 9b illustrates the twining-weave over the first 2 sides of the basket. The shaded line represents the back part of the loop that starts out behind the first group of spokes. The unshaded part represents the front of the loop that starts out on top of the first loop.

Take the top weaver and place it behind the next group of spokes and to the outside of the weaving again. Then take the top weaver from this group of spokes and place it behind the next group of spokes and to the outside of the basket. As you twine, each weaver shifts consecutively from being the top weaver to being the weaver that is behind (see Figure 17b). This twisting of 2 weavers around the groups of spokes is called "twining." As you weave this pattern, repeat to yourself: "The top one goes behind the next group of spokes and to the outside."

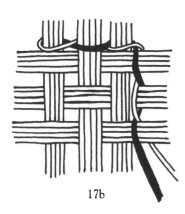

17b

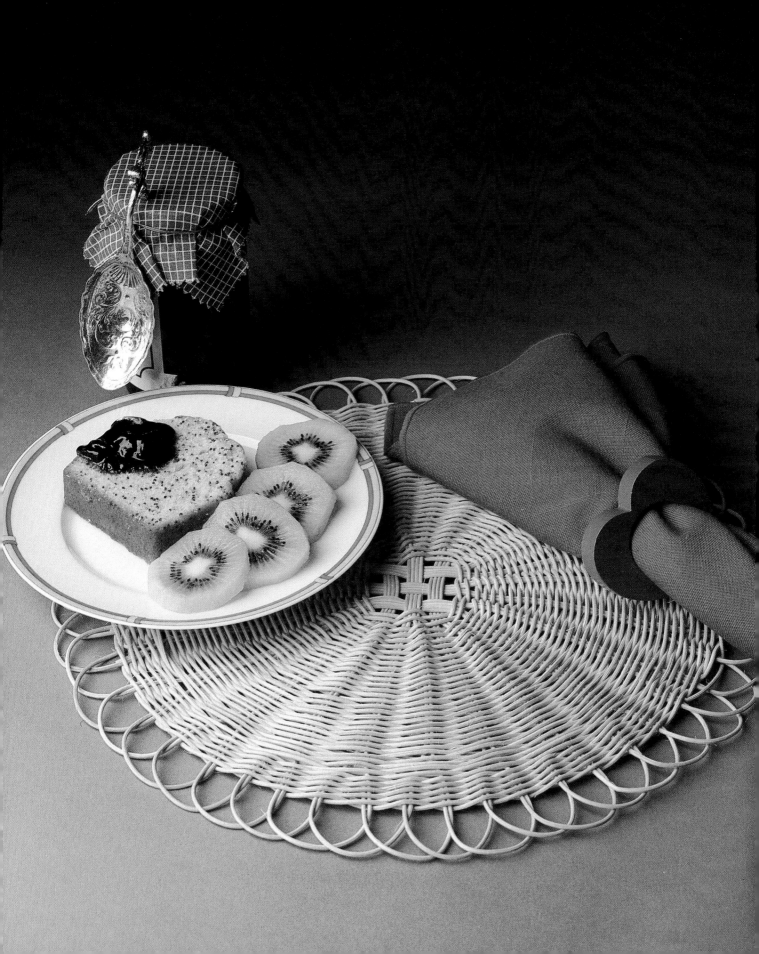

4. With 2 rounds twined over the groups of 4 spokes, start twining over 2 spokes at a time, keeping the spokes flat and in consecutive order (Figure 17c).

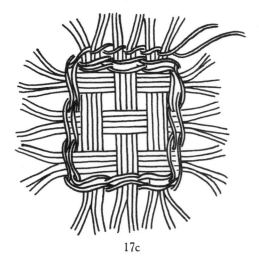

17c

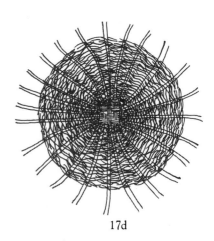

17d

5. Continue twining in this manner, keeping the rows of weaving close together. Spread out the spokes evenly around the perimeter. When 1 weaver is used up, add another by tucking the end into the weaving and adding a new one at the previous pair of spokes. Overlap the ends slightly. When you use up the 2 strands of #1 weavers, continue with #2 weavers. When the mat is 8½ inches in diameter, divide the pairs of spokes and twine on single spokes until the mat is 10 inches in diameter. Trim and tuck in the 2 ends (Figure 17d).

6. To make the border, bend any spoke end to the right and tuck it into the weaving on the right side of the second spoke (Figure 17e). Repeat this procedure around the perimeter of your mat, adjusting the border loops to make them even (Figure 17f).

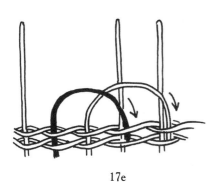

17e

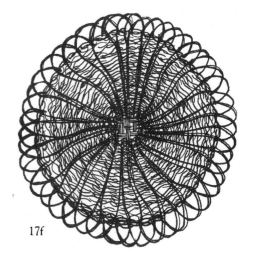

17f

❧18❧
Wicker-Weave Waste Basket

SHAPE round

MATERIALS #1 (6 strands), #4, #6, and #8 round reed (½ pound each)

SIZE 9 inches wide at base, 11 inches wide at top, 12 inches high

INSTRUCTIONS

1. Cut 12 pieces of wet #8 round reed 10 inches long, and cut 1 piece of wet #8 round reed 6 inches long. These will be your base spokes. Cut 25 pieces of wet #6 round reed 23 inches long. These will be your side spokes. The #1 round reed will be used full length as weavers, and additional #4 round reed also will be used as weavers. For maximum flexibility, all reed should be kept wet during the process of weaving. If, as you weave, either the spokes or the weavers become dry and brittle, re-soak the basket for a few minutes until it is flexible once again.

2. Use a hobby knife to pierce the middle of each of 6 wet 10-inch spokes of #8 reed. Holding each spoke on a piece of scrap wood, press the blade carefully into the reed. Using the knife to make the slit wider is very dangerous, so wiggle an awl, or even a small knitting needle, gently back and forth to enlarge the slit to a width of 2 inches.

3. Slide the remaining, unsplit 10-inch spokes through the slits as illustrated in Figure 18a. Cut an angle on the 6-inch piece of #8 and insert it into the base as shown by the arrow in Figure 18a. This extra spoke is used to create the odd number of spokes necessary for weaving in the plain-weave pattern.

4. Adjust the spokes so they measure an even distance from the center of the base. The odd spoke will stick out more than the rest, but retain any extra length until the base is finished, when all spokes will be trimmed. Next, weave 2 rounds to secure the base. Insert a long strand of #1 weaver into the same space with the odd #8 spoke. Bring it over the next 7 spokes, under the following 6 spokes, over the next 6 spokes, and under the last 6 spokes. Weave a second round exactly the same. Because you are weaving over 4 sets of spokes—an even number of sets—the pattern remains the same.

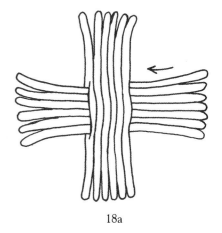

18a

5. Next, reverse direction and go back: over the 6 spokes, under the next 6 spokes, over the next 6 spokes and under the last set of 7 spokes, as shown in Figure 18b. Weave a second round exactly the same.

6. You are now ready to use the plain-weave pattern (over—under—over—under) on single spokes. Be sure that all your spokes are well-soaked so they will not crack. Bring the weaver over and under each of the spokes for 1 complete round. At the same time, fan out the spokes as you weave each stitch, so that this first row of plain-weave will be very close to the 4 rows that secured your base. Weave a second round, continuing to fan out the spokes. On this second round, since you now have an odd number of spokes (25), you will be weaving over the "unders" and under the "overs" of the first row.

After these first 2 rounds, you should have the base fairly well fanned out with evenly spaced spokes (see Figure 18c). This is most important to the entire base structure. For best results, hold each spoke in position as you place the weaver over or under it. Then, with the weaving in place, the spoke will not spring back as far as its original position, but will stay fanned out with the correct spacing. Also, be sure that the spokes are kept flat: if you pull the weaver too tightly or do not keep the spokes flat, your base will be wobbly.

7. Continue weaving the base in plain-weave with #1 weavers until the base is approximately 9 inches in diameter, which should take you just about to the ends of the spokes. Trim and tuck in the end of the #1. Trim whatever spokes stick out flush with the edge of your weaving.

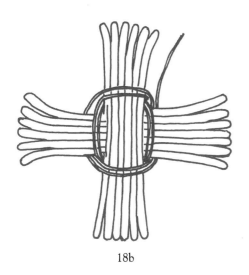

18b

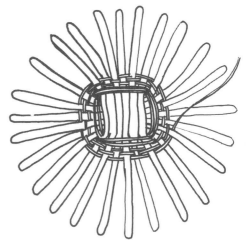

18c

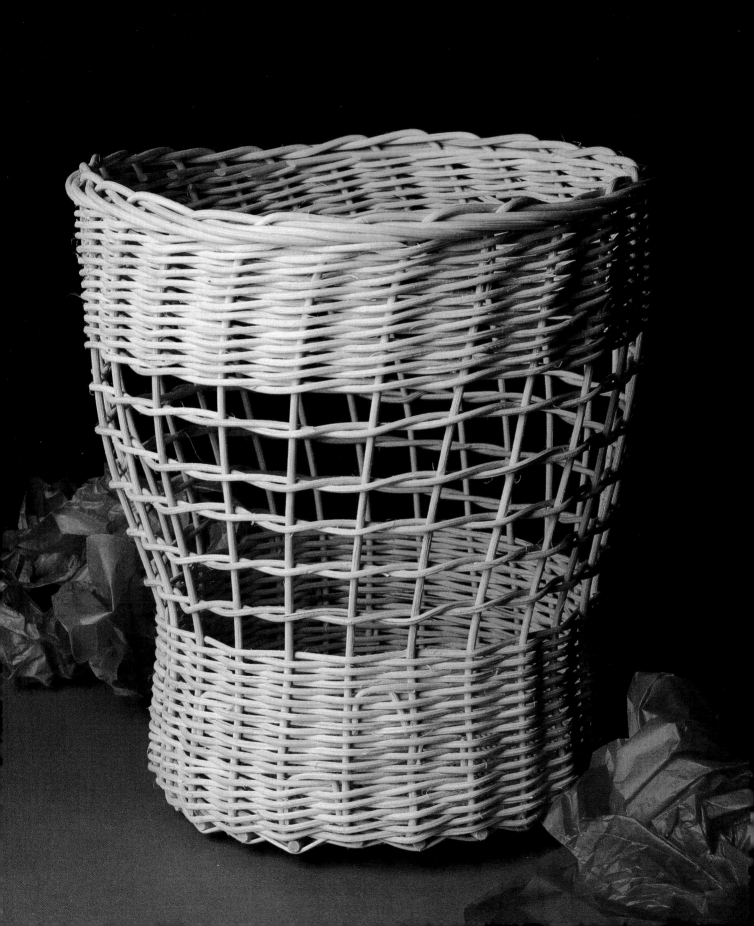

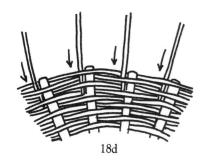
18d

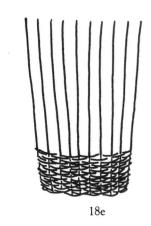
18e

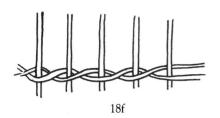
18f

8. To weave the sides of the basket, insert a well-soaked 23-inch spoke of #6 next to each of the 25 base spokes. Push them about 1 inch into the base (see Figure 18d).

9. At the end of your last base row, insert a weaver of #4 round reed. Bending the spokes at a right angle to the base, and pointing the spokes away from you, continue weaving in plain-weave. Weave until the basket is 3½ inches high. As you do so, add additional #4 reed as necessary and gradually create a slightly flared sidewall (Figure 18e).

10. Next, add a second weaver and weave in twining with a ¾-inch space between the rows to create the openwork pattern shown in the illustrations.

11. To weave in twining-weave, have the ends of the 2 weavers running out on top of the rest of the spokes, not inside the basket. Then, take the top weaver and bring it behind the next spoke and to the outside of the basket again. Now take the new top weaver and bring it behind the next spoke and also to the outside of the basket (Figure 18f). As you twine, each weaver shifts consecutively from being the top weaver to being the weaver that is behind. This twisting of the 2 weavers around the spokes is called "twining" or "pairing." When twining, it is most important to keep the ends of the weavers on the outside of the basket. By doing so, it will always be easy to tell which weaver is "behind" and which weaver is on "top."

As you weave this pattern, repeat to yourself: "The top one goes behind the next spoke and to the outside." Weave 6 rows in this manner and then return to solid twining until the basket is 11½ inches high. Trim and tuck in the end of your weaver (Figure 18g).

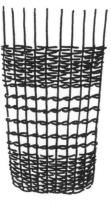
18g

12. Before starting to work on the closed border, soak the spoke-ends well. Start by placing any 1 spoke behind the spoke to its right, and then in front of the next 3 spokes; tuck the spoke end to the inside (Figure 18h). Continuing to the right, repeat these steps with each spoke around the perimeter of the basket. Since this is a "closed" border, slide the reeds down close to the body of the basket, leaving no spaces in the border. (This is the opposite of an "open" border, which would be lacy in appearance.) When the border is completed, trim any excess reed from the spoke ends that lie inside the basket. There should be just enough reed on the inside rim to rest comfortably against the next spoke. The finished basket is shown at Figure 18i.

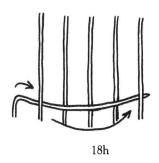

18h

18i

❧ *19* ❧
Ryestraw Baskets

SHAPE round or oval

MATERIALS ryestraw or local fieldgrass (2 shopping bags full), narrow flat reed ³⁄₁₆-inch or ¼-inch wide (½ pound), needle and thread, optional

TOOLS spoon handle

SIZE 10 inches in diameter round or 12 inches long, 2 inches to 5 inches high, as desired

INSTRUCTIONS

1. The first step is gathering and preparing the straw. Ryestraw, or even common mixed-grain roadside materials, may be used for coiled basketry. Cut the grain at ground level and dry it in the sun. When it is thoroughly dry, break off the grain tops, leaving just the stalks. Clean by removing weed stalks and other foreign growth.

When you have finished preparing the straw, gather a bunch of it about ⅝-inch thick and curve the end of the bunch into a tight circle. This ryestraw basket is coiled, and this circle is the center of the basket's base.

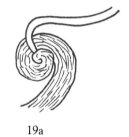

19a

2. Slide an end of wet flat reed into the center of the circle and bring it around to the outside of the coil as illustrated in Figure 19a. If you have difficulty holding the straw in a tight circle, you can use a needle and thread to temporarily sew it together.

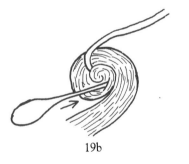

19b

3. Use a narrow spoon handle to make a space in the previous row of coiling (Figure 19b). This space will facilitate working with the flat reed.

4. With the spoon handle still inserted in the coil, bring the flat reed through the space created by the handle and pull the reed up tightly, removing the spoon as you do so (Figure 19c).

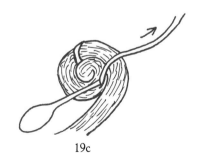

19c

5. Make another space with the spoon handle and continue to lash with the flat reed in the same manner. Add more straw as necessary to keep the coils equally thick. Continue coiling, lashing with the flat reed, and adding straw, until the base reaches the desired size. Your reed stitches should be about 1½ inches apart. When you run

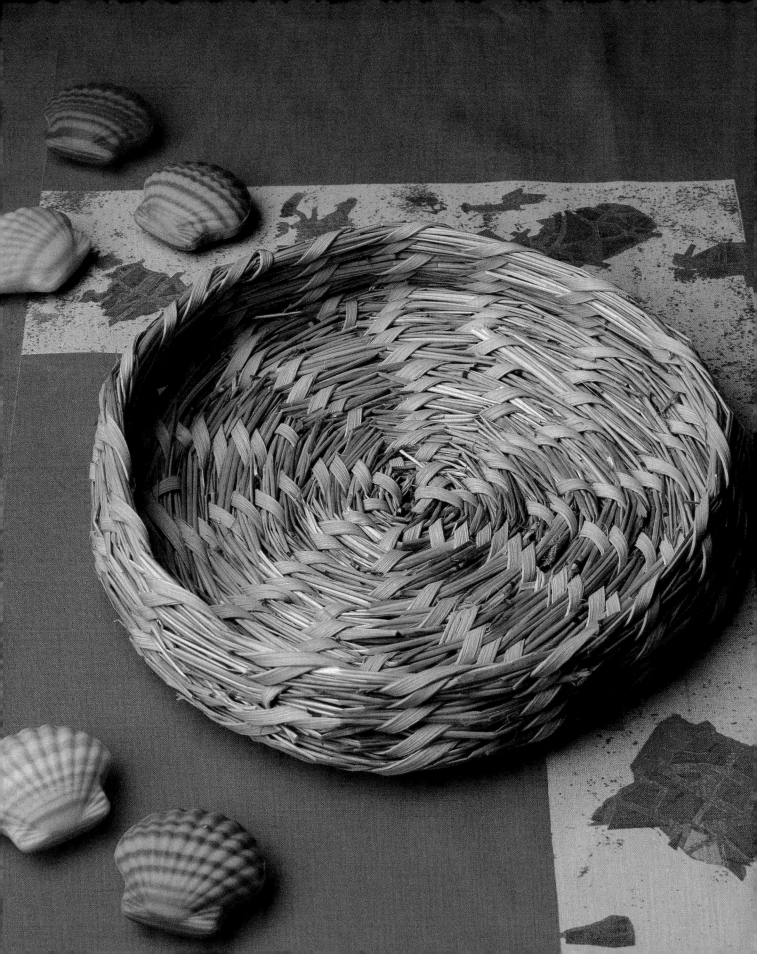

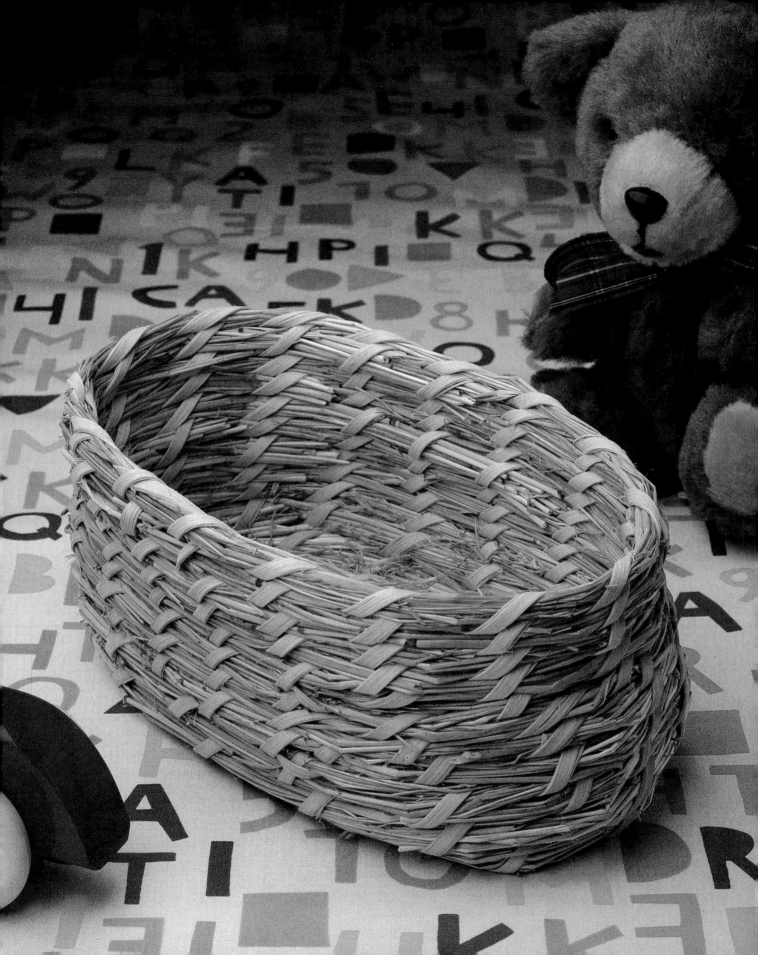

out of flat reed, add a new piece by overlapping its end with the previous piece. Or, hide the end inside the body of the straw, lashing around a couple of times.

6. To create a sidewall for a tray or basket shape, place the straw coil on top of the previous row instead of next to the previous row, and the basket will then go upwards instead of remaining flat. When the desired height is reached, fasten the end of the reed by continuing to lash around the straw until you run out of straw. (The straw will get thinner and thinner.) Then, pull the end tightly inside the reed, lashing on the inside of the basket to secure it (Figure 19d).

For an oval basket, follow the directions for a round basket, but instead of starting with a coiled circle, bend the straw into an oval shape about 5 inches long. Continuing to coil and lash around your base will produce an oval basket.

19d

❧20❧
Covered Splint Basket

SHAPE round

MATERIALS ³⁄₁₆-inch flat reed (½ pound), ½-inch flat reed (several strands), ¾-inch flat reed (½ pound), oak handle with 6½-inch spread

SIZE 7 inches in diameter, 8½ inches high including handle

INSTRUCTIONS

1. Cut 8 pieces of wet ¾-inch flat reed 19 inches long. These will be the spokes of the basket. Notice that the reed has a slightly noticeable "right" side, which is very smooth, and a "wrong" side, which is rougher.

To determine right and wrong sides, flex a spoke into the shape of the letter "U." If it splinters on the outside of the "U," the reed is facing wrong side out. If the reed stays smooth and few fibers pop up, the reed is positioned with the right side out. These right and wrong sides usually have no bearing on the weaving of the basket. However, because the spokes will be turned down at the top to secure the weaving, the basket will have a smoother, more attractive appearance if the rough side of all spokes is on the inside of the basket and the smooth sides on the outside.

20a

2. With the rough side facing up so that it will be inside the basket, lay out your base pattern. Place a cross of 2 spokes upon another cross of 2 spokes, then add a third and a fourth cross of spokes, making a total of 8 spokes. With a piece of string or raffia, weave over and under all 16 spoke ends to secure the base temporarily. Remove this string when you finish weaving. Adjust the spoke length so that all spokes are equally distant from the center of the base. Then, using a pair of scissors, split any 1 spoke in half and thus create the odd number of spokes necessary for the plain-weave pattern (Figure 20a).

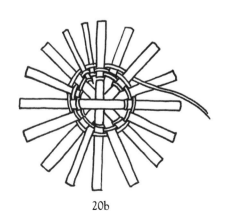

20b

3. Insert a wet weaver of ³⁄₁₆-inch flat reed at the split spoke and, for the first round, plain-weave directly in the path of the string: over—under—over—under. Continue weaving in plain-weave until the base measures 5½ inches in diameter (Figure 20b).

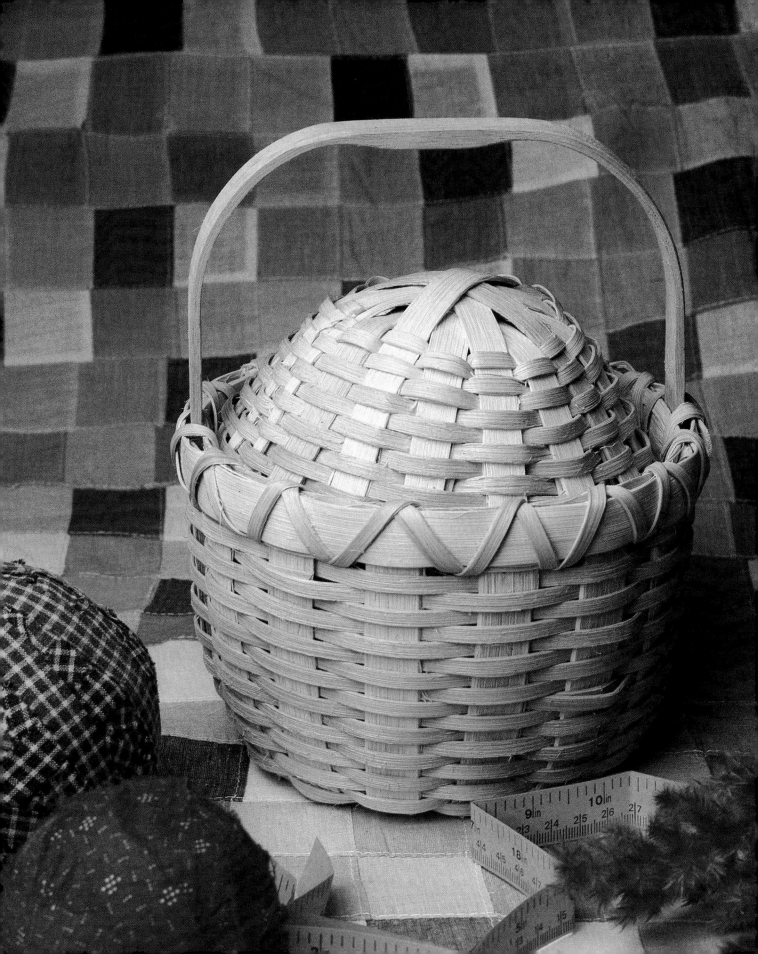

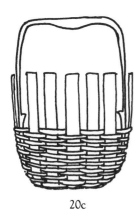

20c

20d

4. Now shape the sides of the basket by holding the spokes at a right angle to the base. The basket bottom should be in your lap with the spokes pointing away from you. Be sure that the rough side of the spokes is still inside the basket. As you weave, pull the weavers more firmly to tighten the spokes into an upright position, but take care not to pull too tightly or your basket will slant inward. If "bubbles" or loose spots appear in the weaving, stop and adjust the weaver—either tighter or looser as necessary—before proceeding.

5. When the basket is about 3 inches high, slide the basket handle into the weaving on the inside of the spokes (Figure 20c). Continue weaving smoothly, fixing the handle tightly into place. Weave until you have completed 3 rows above the notch of the handle. The basket should stand about 4¾ inches high at this point.

6. Soak the basket for about 20 minutes. Carefully bend each spoke towards the inside of the basket, and weave it into the body of the basket (Figure 20d). Adjust and trim the spokes where necessary so that their ends will be hidden behind weavers.

7. To make the basket bands, cut 2 pieces of wet ¾-inch flat reed to fit the inside and outside circumferences of the basket with about 1½ inches overlap. Use clothespins to position the bands directly on top of (not above) the last 3 rows of weaving. The bands will nestle into the "shelf" of the notch. At the same time, place the overlapping ends of the inside border bands on the opposite side of the basket from the overlapping ends of the outside bands. This will prevent any undue bulk in the reed (Figure 20e).

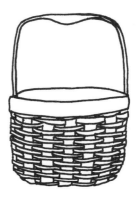

20e

8. To lash the border bands, take a well-soaked length of ³⁄₁₆-inch flat reed and slide it under the rim and in between the layers of the bands. Bring the reed diagonally to either the right or left, carrying it around the inside and outside borders of the basket. Bring it once again under the rim, above the last row of weaving and to the outside of the basket. Continue in this manner to lash around the entire basket border. Figure 20f illustrates this lashing, with the dotted lines showing the path of the cane on the inside of the basket. If desired, lash a decorative "X" at the basket handles. When you reach the point at which you began to lash, reverse, and lash in the opposite direction, completing the zigzag pattern of the reed. Slide the reed firmly into the core of the bands, pull tightly, and trim the end.

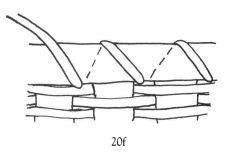

20f

Covered Splint Basket

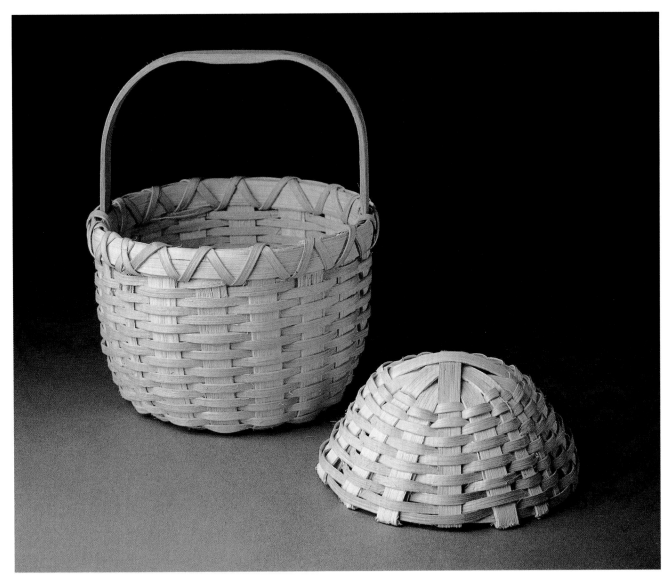

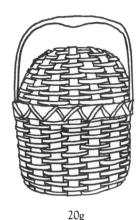

20g

9. For the basket cover, cut 8 pieces of wet ½-inch flat reed, making each piece 12 inches long. These will be the spokes of the cover.

10. Lay out a spoke pattern identical to that of the basket base (see Steps 2 and 3), also temporarily fastening the cover spokes with string or raffia.

11. Split 1 spoke with a pair of scissors to create an odd number of spokes. Insert a weaver of wet ³⁄₁₆-inch flat reed and begin weaving the cover. Almost immediately, pull the spokes into the bowl shape required for the cover (see Figure 20g). Using the illustration as a reference and your own basket as a guide to the appropriate proportions, weave until you have a bowl shape measuring 6 inches in diameter—or whatever size will fit the interior of your basket comfortably. When finished, the cover should rest lightly on the inside of the basket rim. The cover of the sample basket is approximately 3 inches deep.

12. Soak the cover well before bending down the spokes. Then, carefully bend each spoke towards the inside of the cover and weave it into the body of the basket as shown in Figure 20d. Adjust and trim each spoke so that its end will be hidden behind a weaver.

❧ *21* ❧
Fish Trap Basket

SHAPE cylinder

MATERIALS ½-inch flat reed (½ pound), ³⁄₁₆-inch flat reed (½ pound), #6 round reed (1 strand), medium cane (1 strand)

SIZE 5 inches wide at base, tapering to a width of 3¾ inches at top; 15 inches high

INSTRUCTIONS

1. Cut 8 spokes of wet ½-inch flat reed 36 inches long. Cut 2 pieces of ½-inch flat reed 14 inches long. These 2 pieces will be used as border bands; put them aside until the weaving of the basket is completed. The ³⁄₁₆-inch flat reed will be used full length as weavers. A short length of #6 (approximately 13 inches long) will be attached to the top bands, and a strand of medium cane will be used to lash on the #6 and the flat reed border bands.

2. Lay out the basket base by placing two 36-inch spokes at right angles to form a cross. Then, place 2 additional spokes in a cross on top of the first cross. Finally, add a third and fourth cross and place them on top of the first 2 crosses to complete the base. Figure 21a illustrates the base layout without showing the full length of the spokes.

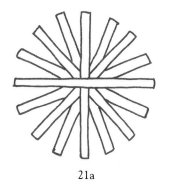

21a

Use a piece of twine to weave over and under the spokes and temporarily hold the base pattern together. Pull up tightly, tie a knot, and trim the twine. Remove the twine when the basket is finished.

3. Check the spokes to be sure that each one measures about 18 inches from the center of the base to its end. Realign any spokes that are uneven. There will be a total of 16 spokes around the base. Because the plain-weave pattern requires an odd number of spokes, 1 spoke will have to be split in half to make 2. Be sure to split any spoke that is not a top or bottom spoke, so that the split spoke will not make the basket sit unevenly. With a pair of scissors, carefully cut the spoke in half lengthwise from its end all the way to the twine.

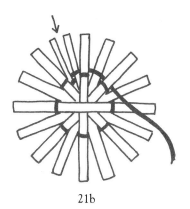

21b

4. Start weaving by tucking a wet strand of ³⁄₁₆-inch flat reed into the split spoke. Weave over—under—over—under in plain-weave tightly around the base. Keep the spokes evenly spaced and the rows of weaving close together (see Figure 21b). The arrow points to the

split spoke. When the base is 5 inches in diameter, bend the spokes upright and tapered slightly inward. Keep in mind the finished silhouette of the basket. If you pull the spokes in too tightly or loosely as you begin to weave, you will be unable to correct the error in later rows. So, from the turn of the base, keep your weaving smooth and the spokes evenly spaced and gently tapered inward. A very slight inward taper is all that is necessary because your basket, which is now 5 inches wide at the base, is going to narrow to an opening 3¾ inches wide at the top. The decrease in diameter is only 1¼ inches, so you'll need to measure frequently to ensure weaving the correct shape.

5. If the basket becomes dry, re-soak it before continuing to weave. When you use up a weaver, add a new weaver by overlapping the ends about 2 inches. Because the basket tapers inward, the spokes will gradually grow closer and closer together as you get nearer to the top. When the basket is 14 inches high, add the border bands. Do not cut off the spoke ends that stick out at the top.

6. To make the border bands, use two clip clothespins to hold one 14-inch piece of ½-inch flat reed on the outside of the basket and the other 14-inch piece of ½-inch flat reed on the inside of the basket. The overlapping ends of the bands should be on opposite sides of the basket, and the bands should rest against the spokes immediately above the weaving. Trim any spoke ends that might stick out above the bands. Then, take the piece of #6 round reed (approximately 14 inches long) and lay it along the top circumference. Use the same clothespins to clip it on temporarily. Figure 21c shows the top of the basket with the ½-inch flat reed bands and the #6 round reed ready to lash on. If the #6 is too long, make no adjustments to its length at this point.

21c

7. Thread a strand of wet medium cane through the basket from the inside to the outside and use it to lash on the borders. Sew the border pieces on as shown in Figure 21d, pulling up firmly. Keep the shiny side facing out and work in one direction all around the rim. Bring the cane under the top row of weaving on every third stitch to anchor the border. The dotted lines in Figure 21d show the path of the cane on the inside of the basket. Re-soak the cane and basket top if they become brittle.

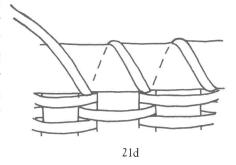

21d

8. Remove the clothespins as you sew past them. Keep the cane tight. When you reach the cut ends of the #6, use pruning shears to carefully cut the ends at complementary angles so that they butt tightly against each other. Make them butt together very tightly because, as the basket dries, the reed will shrink slightly and the #6 will then dry to just the right length. After circling the border once, work back in the opposite direction to complete the zigzags. Fasten the end by tucking over and under and securing the ends inside before trimming off the extra cane (Figure 21e).

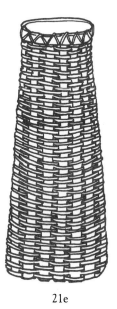

21e

❧ 22 ❧
Herb- or Flower-Gathering Basket

SHAPE rectangular

MATERIALS ¾-inch flat reed (½ pound), ¼-inch flat reed
(½ pound), #6 round reed (1 strand), oak handle with 12- 13-
inch spread

SIZE 19 inches long, 13 inches wide, 13 inches high including
handle

INSTRUCTIONS

1. Cut 12 pieces of ¾-inch flat reed 28 inches long. These will be
the spokes for the length of the basket. Cut 7 pieces of ¾-inch flat
reed 32 inches long, 4 pieces of ¾-inch flat reed 28 inches long, and
4 pieces of ¾-inch flat reed 24 inches long. These 15 pieces will be
used for the side spokes for the width of the basket. Their different
lengths will accommodate the curved shape of the sides.

2. Lay out the base pattern as shown in Figure 22a, being careful to
keep the rough side of the reed facing up for use as the inside of the
basket. With a length of raffia or string, weave over and under the
spokes to secure the base pattern. The base perimeter should measure
12½ inches × 16½ inches. Split any single corner spoke with a pair
of scissors to make 2 spokes and create the odd number of spokes
necessary for plain-weave.

3. Using a clip clothespin to temporarily hold it in place, insert a
weaver of ¼-inch flat reed at the split spoke, and weave for 5 rounds.
On the sixth round, weave the first long side of the basket, the first
short side of the basket, the second long side of the basket, and then,
on the last short side, weave over and under only the next 5 spokes.
At this point, reverse direction and weave back over those 5 spokes.
Continue the round to the opposite short end of the basket, and
weave over the other ends of the same 5 spokes.

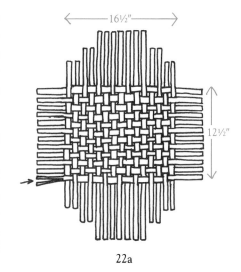

22a

4. You have just divided your basket in half lengthwise. Before tapering the ends and sides of the basket, insert the notched handle on the inside of the weaving at the eighth spoke, sliding it down to the fourth row (Figure 22b).

5. Then reverse direction and continue to weave around ½ of the basket until you return to the place where you first reversed over 5 spokes. This time, reverse back over 4 spokes. Then, weave down the long side, turn the corner, reverse and weave back over 4 spokes on the opposite end. Next, weave back and reverse over 3 spokes on each short end, then 2, and finally 1 (Figure 22c).

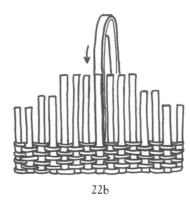

22b

22c

6. You are now at the corner of the basket, and will continue in a slightly different pattern to curve the edges on the long side of the basket. Continue weaving across the long side, reverse, and weave back over the first 3 spokes on each end, just as you did on the short ends.

7. Continue weaving, but this time weave back twice on the next 6 outside spokes (fourth, fifth, sixth, tenth, eleventh, and twelfth spokes) as shown in Figure 22d (handle not shown).

8. Inserting a weaver on either short end of the basket, weave the opposite side of the basket to match. Figure 22e shows the narrow end of the basket with the shaping woven.

22d

22e

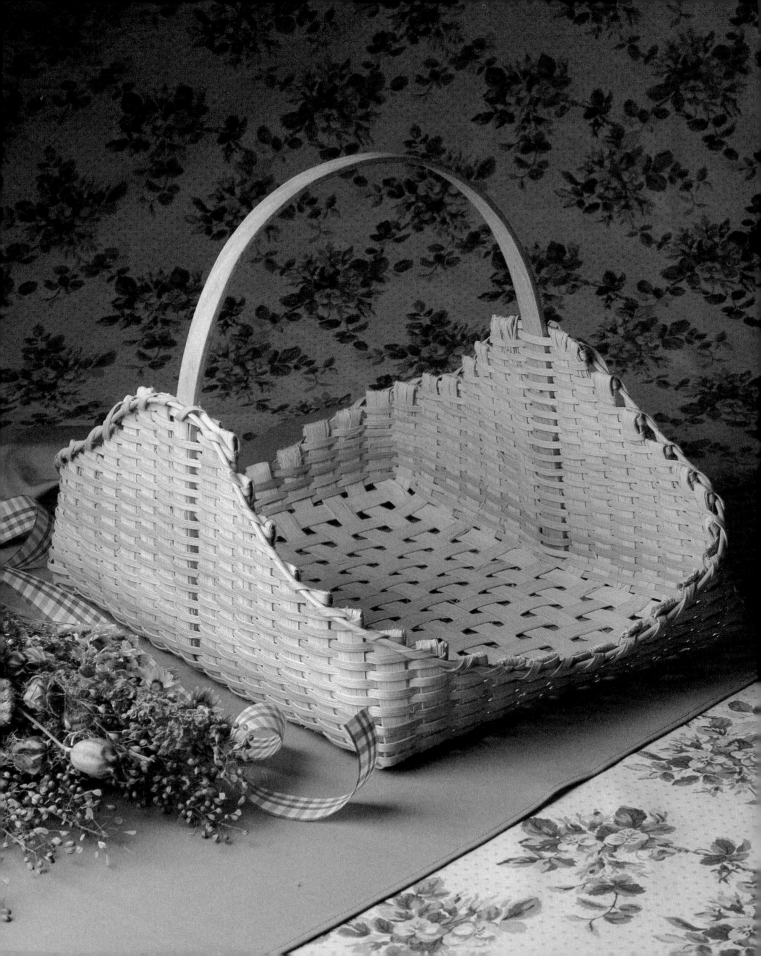

22f

22g

9. Soak the basket well to soften the spokes for finishing. Bend any spoke end towards the inside of the basket, over the last row of weaving, and tuck the end down securely into the woven pattern (Figure 22f). Widen the space at each spoke with an awl as you go along. After you've tucked in a few of the spoke ends in this manner, you'll be able to judge how long these spokes should be to enable you to finish off with the least amount of friction—usually about 1½ inches is enough. Trim off any excess length. Once you have repeated this procedure around the circumference of the basket, your basket border will be squared off at each spoke in a staggered pattern.

10. Use clip clothespins to attach a length of #6 round reed to the outside of the basket, beginning and ending at any handle. Don't trim off any excess length until the border is lashed in place, for it will shrink a bit more as it dries. Use a ¼-inch flat reed (shown shaded in Figure 22g) to lash on this border at each spoke just under the top row of weaving. At each spoke trim the end of the #6 reed to overlap an inch or 2, as desired. Figure 22h shows the completed basket.

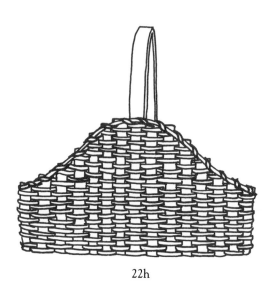

22h

❧23❧
Doll Cradle or Teddy Bear Bed

SHAPE hooded rectangle

MATERIALS ½-inch flat reed (½ pound), ¼-inch flat reed (½ pound), medium cane (3 strands)

SIZE 7 inches long, 12 inches wide, 9 inches high

INSTRUCTIONS

1. From wet ½-inch flat reed, cut 7 pieces 29 inches long, 9 pieces 14½ inches long, and 4 pieces 34 inches long. These will be your spokes. Additional ½-inch flat reed will be cut to size for the bands and also will be used for the curly decoration. The ¼-inch flat reed will be used full length as weavers. Medium cane will be used to lash on the basket bands.

Doll Cradle or Teddy Bear Bed

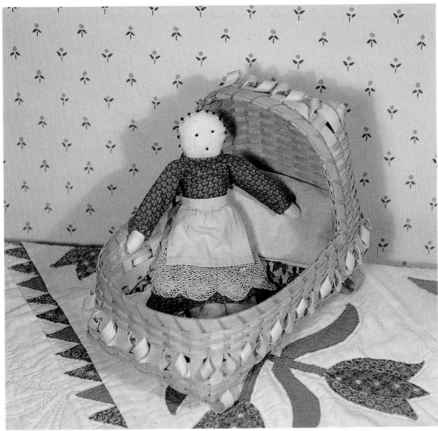

2. Carefully lay out the 20 base spokes in a plain-weave pattern according to the measurements in Figure 23a. The square spaces between the spokes should measure ³⁄₁₆ inch. Temporarily fasten the base together by weaving in a piece of string or raffia (as shown), and split the spoke where indicated by an arrow at the left-hand side of Figure 23a.

3. Insert a strand of ¼-inch flat reed weaver at the split spoke, holding the spokes at a right angle to the base, weave 4 rounds, keeping the tension smooth and firm. Cut the ¼-inch weaver, and tuck the end inside the basket (Figure 23b).

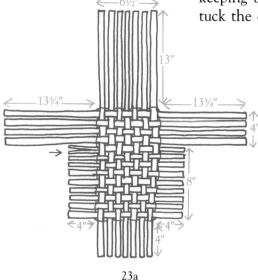

23a

23b

4. Insert a strand of ½-inch flat reed and weave 1 round to use as a foundation for the curly decoration. When you return to the split spoke, go under 2 spokes so that you can place the ½-inch flat weaver in the same path for 1 stitch. Then flex it into a curl, as illustrated in Figure 23c, and carry it up and behind the second spoke. Bring it out to the front again with a second curl. Then, bring the reed behind the next spoke which is the same path as the previous round and repeat the curling for the rest of this second round. (In Figure 23c, the first round of ½-inch flat reed is represented by the shading. The second round—which is the curly—is the unshaded weaver.) Cut and tuck the ½-inch flat weaver.

23c

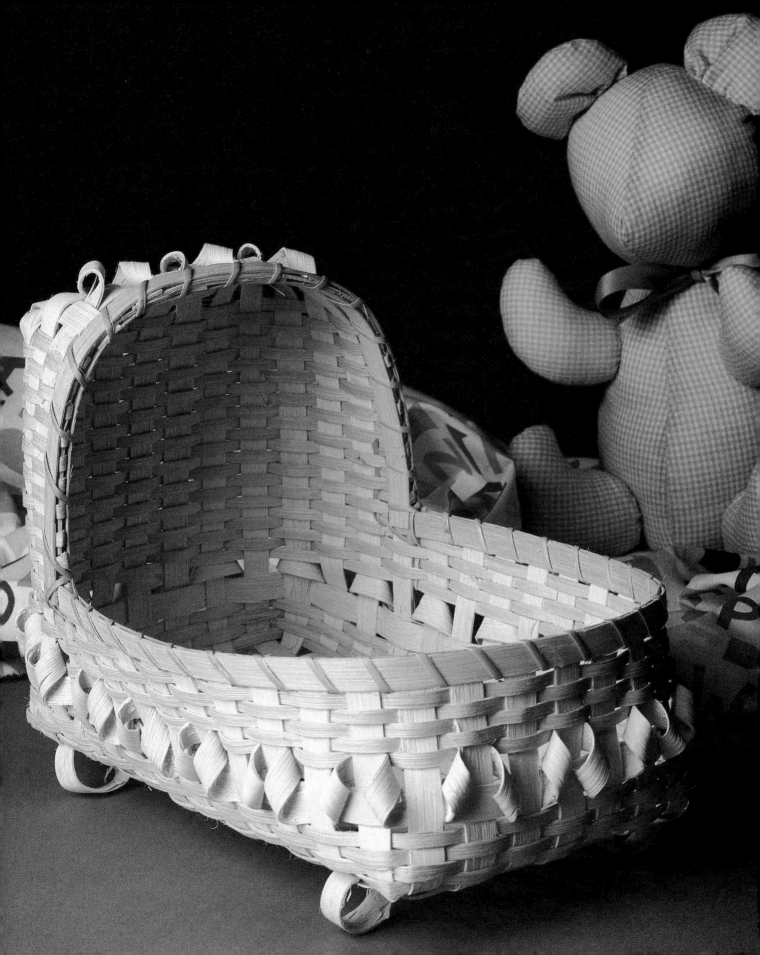

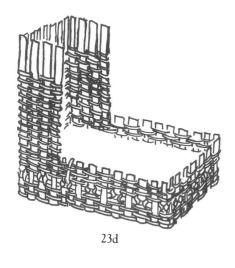

23d

5. Resume weaving with ¼-inch flat reed for 5 rows around the entire perimeter of the basket.

6. After 5 rounds, weave the hood of the cradle. Treating the split spoke as 1 spoke, weave back and forth over the 4 side spokes, 7 rear spokes and last 4 side spokes for 22 rows (Figure 23d).

7. To weave the hood top, bring the 4 left-hand and 4 right-hand side spoke ends towards each other and interweave them into a plain-weave top. At the same time, insert an extra piece of ½-inch flat reed and weave a curly decoration that connects the second and third rows. Trim the spoke ends flush with the edge of the hood. Figure 23e shows the completed hood top as viewed from above.

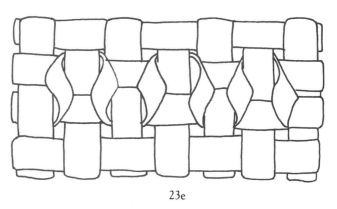

23e

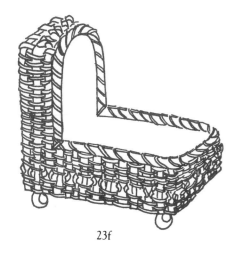

23f

8. Using clip clothespins, attach bands of ½-inch flat reed directly on top of the last interwoven spoke set on the hood front (row 4). Place 1 piece inside and 1 piece outside. Similarly, attach bands of ½-inch flat reed on both the inside and outside of the bottom of the cradle, directly above the last row of weaving. Trim the spoke ends that extend above the bands. Use the medium cane to firmly lash diagonal stitches around the entire perimeter of the cradle opening. Lash crosses at the 2 inside corners. Weave the cane end into the basket-weaving and trim the end (Figure 23f).

9. To attach rocker feet to the cradle, cut 4 pieces of ½-inch flat reed, each 5 inches long. Then thread each piece through the basket bottom at the second spoke from each end, making a loop. The loops of reed will dry to make a very firm foundation.

❧ 24 ❧
Footed Wool-Drying Basket

SHAPE rectangular

MATERIALS ten ¾-inch oak splints 8 feet long, twelve ½-inch oak splints 8 feet long, two ¼-inch oak splints 8 feet long, ⅝-inch half round reed (1 strand), 4 basket feet, 2 bushel basket handles with 5½-inch spread

SIZE 18 inches long, 15 inches wide, 16 inches high to the rim

INSTRUCTIONS

1. Well-soaked splints are critical to the success of your basket. The age and dryness of your splints will determine how long they should be soaked. Oak splints generally require 5 or 6 hours of soaking in preparation for weaving. If you stop weaving for a day, 3 hours of re-soaking may be required to restore flexibility. Should you notice signs of cracking, soak again and test an hour later.

After soaking has been completed, cut 9 splints of ¾-inch oak, each 34 inches long; cut 12 splints of ¾-inch oak, each 30 inches long. These will be your spokes. The ½-inch oak will be used as weavers.

2. With the 21 well-soaked spokes, lay out the rectangular base as shown in Figure 24a. Be sure to place the rough side of the splint facing up so that it becomes the inside of the basket. Lash the base into position temporarily with raffia or string. The base weaving should measure 11¼ inches × 14½ inches.

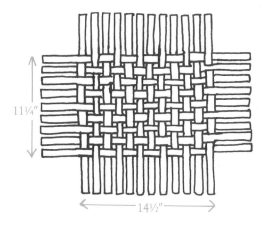

11¼″

14½″

24a

3. Using a length of ½-inch splint, start at any corner and weave one round in plain-weave: over—under—over—under. Place the smooth side of the weaver on the outside of the basket. Carefully flex the spokes at a right angle to the base in order to prepare for a smooth transition from the base to the sides. When you return to the place where you began weaving, insert a second length of ½-inch oak splint as shown in Figure 24b, and weave a second round. Because we have an even number of spokes and we're choosing not to split a spoke to create the usual odd number, we will use 2 weavers consecutively to produce a plain-weave pattern.

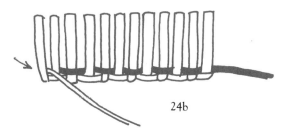

24b

At the same time, insert the basket feet on the second round at the corners, blending them into the weaving with the first and last side spokes, as indicated in Figure 24d. Basket feet may be purchased or hand-crafted at home. Ours are hand-cut pine, stained to complement the oak. See Figure 24c for suggested shaping. We used a piece of pine measuring 1 × 1¼ inches × 13 inches. A shelf was notched into the approximate midpoint of the pine, and then the top piece (to be woven into the basket) was trimmed to taper from a thickness of ¼ inch at the shelf to ⅛ inch at the top. The beveled tops of the basket feet will be incorporated into the weaving on the outside of the basket. Adjust the weavers so that the feet are tightly held in place by the weaving, with the body of the basket sitting on the shelf created by the notch (see Figure 24c) of the feet.

24c

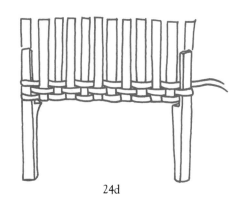

24d

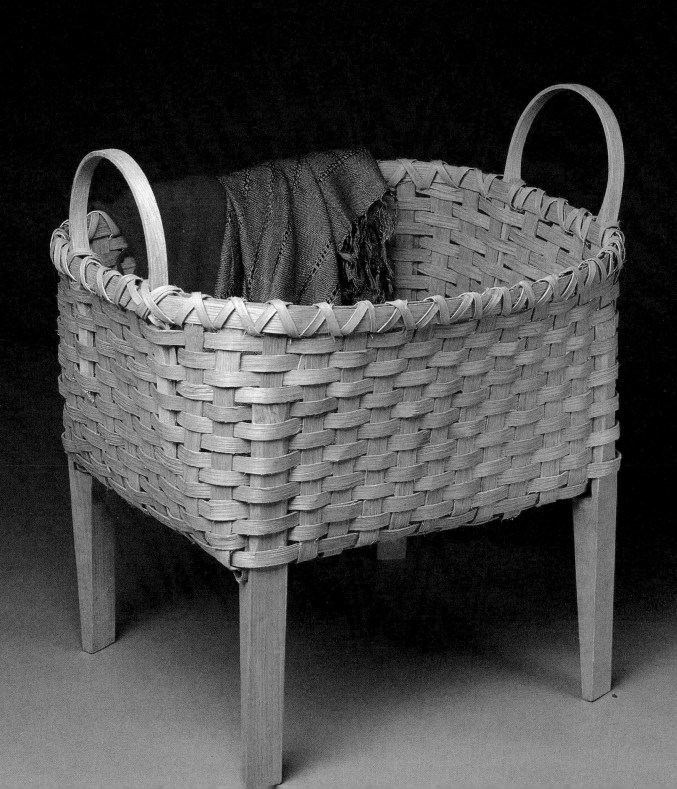

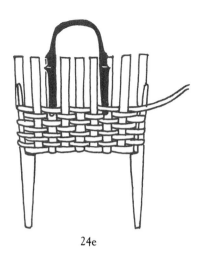

24e

24f

4. Weave a total of 8 rounds with the 2 weavers. Then, insert the tips of the bushel basket handles into the weaving on the outside of the basket in the path of the third and seventh end spokes. Place the notched edges towards the outside of the basket (Figure 24e).

5. Continue weaving until the basket is 8 inches high (16 rounds), taking care to incorporate the handles smoothly. Trim the ends of the weavers with a long, tapered angle, and finish off as shown in Figure 24f.

6. Measure lengths of ¾-inch splint for the inside and outside bands of the basket. Using clip clothespins to position the bands for lashing, place the bands directly on top of (not above) the last row of weaving, and sandwich the handles inside the bands. Because the woven basket is not perfectly horizontal, the bands will be used to produce an even top rim. Assess the shape of the basket visually and level the top rim by placing the basket bands higher or lower on the weaving as necessary. If you don't trust your eye, use a carpenter's level to confirm that the bands are positioned horizontally. Trim the spoke ends, keeping their edges flush with the top of the rim (Figure 24g).

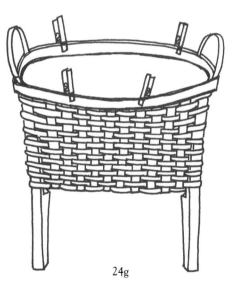

24g

7. Insert a length of ¼-inch splint between the layers and lash on the bands with diagonal stitches, remembering to prevent splintering by keeping the smooth side on the outside. Bring the ¼-inch splint around the layers of bands and weaving, placing 1 stitch in between each spoke around the circumference of the basket. (The dotted lines in Figure 24h illustrate the path of the lashing on the inside of the basket.) At the opposite side, reverse, and lash in the opposite direction to form zigzags. Tuck in the end of the splint and pull up tightly. Trim the ends.

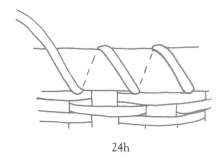

24h

8. To reinforce the base, cut 2 pieces of ⅝-inch half-round reed diagonally to measure across the bottom of the basket. The ends should tuck into the spoke pattern at the notched shelf. Mark the path of their overlapping cross, remove from the basket, and cut notches (Figure 24i) for a smooth fit. Re-insert into the corners. The flat sides of the half-round reed should rest against the bottom of the basket (Figure 24j).

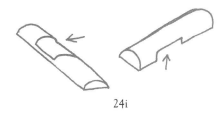

24i

24j

Footed Wool-Drying Basket

Gathering Basket
❧ 25 ❧

SHAPE rectangular

MATERIALS ten ¾-inch oak splints 8 feet long, twelve ½-inch oak splints 8 feet long, four ¼-inch oak splints 8 feet long, 2 bushel basket handles with 5- 6-inch spread

SIZE 19 inches long, 14 inches wide, 8 inches high without handles

INSTRUCTIONS

1. Well-soaked splints are critical to the success of your basket. The length of soaking time required depends upon the age and dryness of your wood. Oak splints generally require 5 or 6 hours of soaking in preparation for weaving. If you stop weaving for a day or so, 3 hours of re-soaking may be required to restore flexibility. If you notice signs of cracking, soak again and test an hour later.

After you have finished soaking, cut 8 splints of ¾-inch oak, each 34 inches long. Cut 12 splints of ¾-inch oak, each 27 inches long. These will be your spokes. One-quarter-inch oak splints will be used as the beginning weavers and for lashing on the border bands. The ½-inch oak splint will be used for weaving most of the basket.

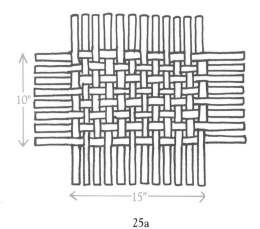

10"

15"

25a

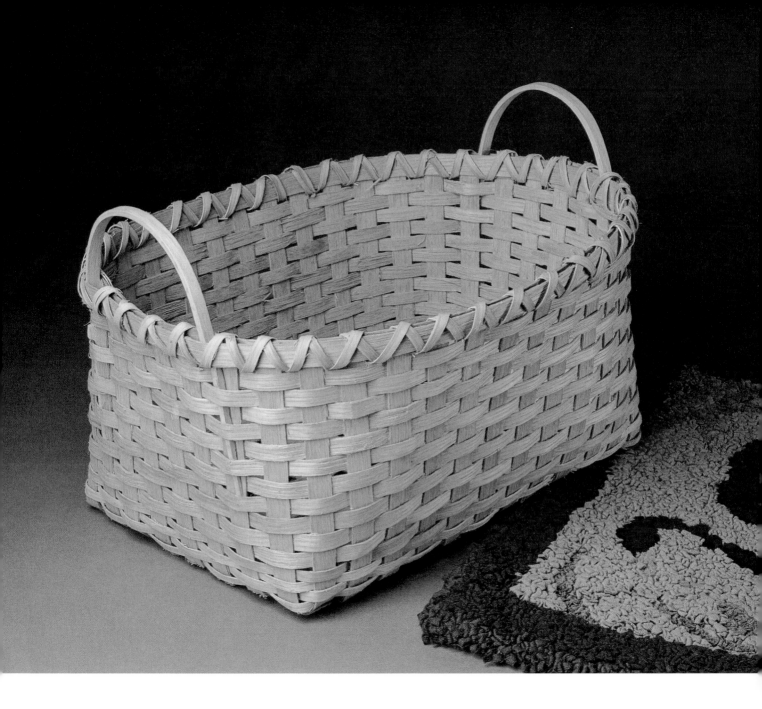

2. Following Figure 25a, lay out a rectangular base with the 20 well-soaked spokes. As you work, keep the rough side of the splint facing up so that it becomes the inside of the basket. Lash over and under the spokes with raffia or string to temporarily secure the base pattern. When finished, the base perimeter should measure 10 inches × 15 inches.

3. Using a length of ¼-inch splint and keeping the smooth side of the weaver on the outside of the basket, start at any corner and weave

1 round in plain-weave: over—under—over—under. Carefully flex the spokes at a right angle to the base in order to prepare a smooth transition from the base to the sides. When you return to the place where you began weaving, insert a second weaver of ¼-inch splint (see Figure 25b), and weave a second round. Because we have an even number of spokes and we're choosing not to split a spoke to create the usual odd number, we will use two weavers consecutively to produce a plain-weave pattern.

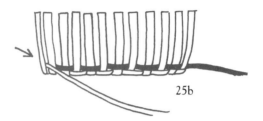

25b

4. Weave with the two ¼-inch weavers for 2 more rounds, making a total of 4 rounds of ¼-inch splints. Trim any extra length. Overlapping the ends, use ½-inch splints to continue the weaving. Shape your weaving to produce a basket with sides that taper upward at a slight angle.

5. When the basket is 5 inches high, insert the tips of the bushel basket handles into the weaving on the outside of the basket in the path of the second and seventh end spokes. Place the notched edges towards the outside of the basket (Figure 25c).

6. Continue weaving until the basket is 8 inches high (16 rounds), taking care to incorporate the handles smoothly. Trim the ends of the weavers with a long tapered angle, and finish off as shown in Figure 25d.

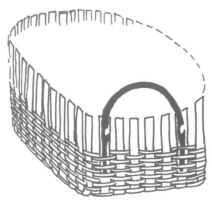

25c

25d

7. Measure lengths of ¾-inch splint for the inside and outside bands of the basket. Use clip clothespins to position the bands for lashing: place the bands directly on top of (not above) the last row of weaving, and sandwich the handles inside the bands (Figure 25e). Because the woven basket is not perfectly horizontal, the bands will be used to produce an even top rim. Assess the shape of the basket visually, and level the top rim by placing the basket bands higher or lower on the weaving, as necessary. If you don't trust your eye, use a carpenter's level to confirm that the bands are positioned horizontally. Trim the spoke ends, keeping their edges flush with the top of the rim.

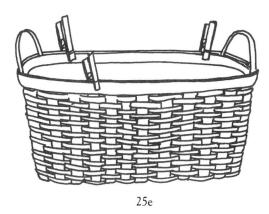

25e

8. Insert a length of ¼-inch splint between the layers and lash on the bands with diagonal stitches, remembering to prevent splintering by keeping the smooth side of the splint on the outside of the basket. Bring the ¼-inch splint around the layers of bands and weaving, placing 1 stitch in between each spoke around the circumference of the basket. Figure 25f illustrates the initial stitches; the dotted lines show the path of the splint on the inside of the bands. With 1 round complete, reverse, and lash diagonal stitches in the opposite direction to form the zigzags, which complete the basket (Figure 25g).

25f

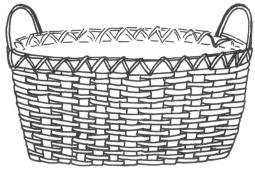

25g

❧ Index ❧

꙰

All of us at Meredith® Press are dedicated to offering you, our customer,
the best books we can create. We are particularly concerned
that all of the instructions for making projects are clear and accurate.
Please address your correspondence to Customer Service Department,
Meredith® Press, Meredith Corporation,
150 East 52nd Street, New York, NY 10022.